759.2

Pictures by David Hockney

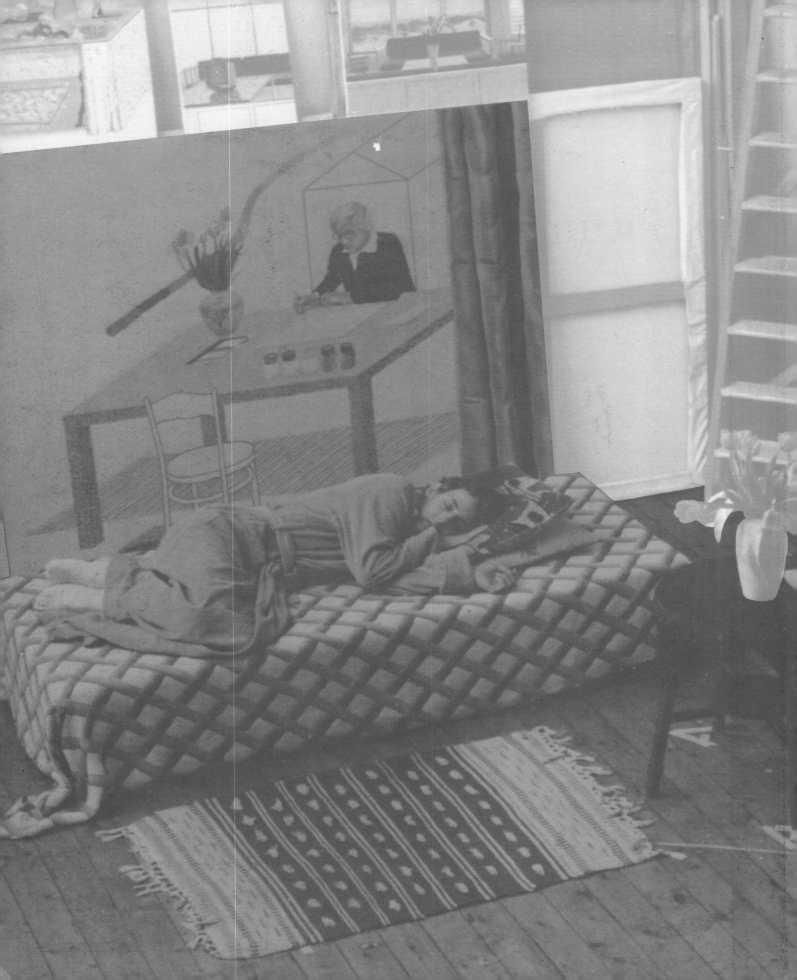

Pictures by David Hockney

Selected and edited by
Nikos Stangos

with 144 illustrations
61 in colour

Thames and Hudson

Title page photograph by David Hockney taken in his
London studio (1977) with Gregory Evans, his model, on
the couch (left), in front of *Self Portrait with Blue Guitar*,
and, on the right, *Model with Unfinished Self Portrait*
(unfinished state).

Reprinted 1988

Printed and bound in Great Britain by Balding & Mansell,
Wisbech, Cambs.
Filmset in Great Britain by Keyspools Limited, Golborne,
Lancashire.

Contents

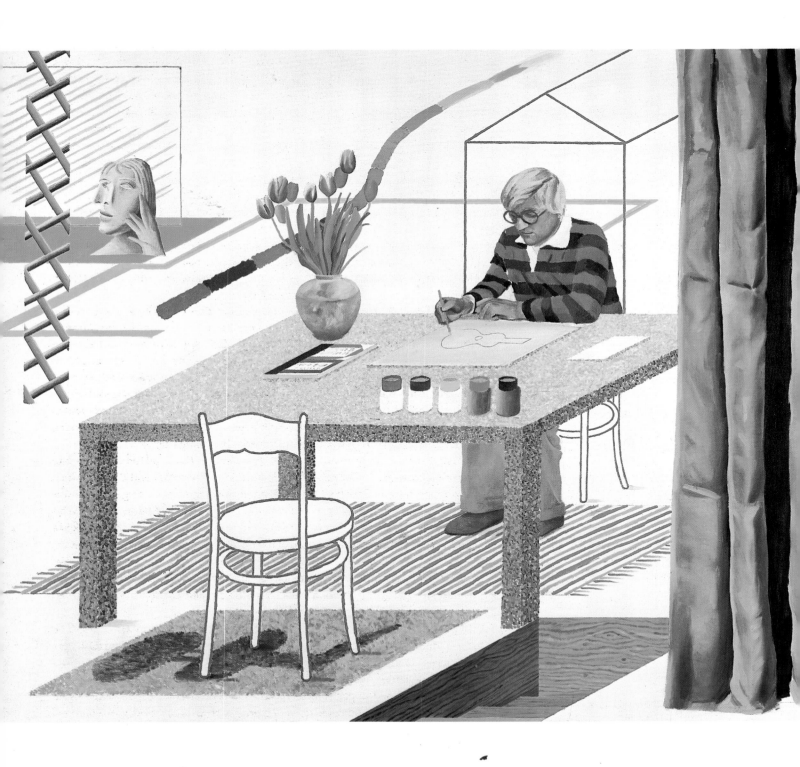

Introduction by David Hockney

It is very good advice to believe only what an artist does, rather than what he says about his work. Any respectable art historian would never go only by an artist's words; he would look for evidence of them in his work. I think it was Sickert who said somewhere, Never believe what an artist says, only what he does; then he proceeded to write a book. After an artist has done the work, it's reasonably easy to theorize about it, but to theorize about it beforehand could be disastrous. I don't think one should do it even if one has the inclination. People interested in painting might be fascinated by an artist's statements about his work, but I don't think one can rely on that alone to learn about an artist's work, which is all trial and error.

I was born in Bradford in 1937. Until I was eleven, I went to the local council school, where my brothers and sister went. Then I went to Bradford Grammar School on a scholarship. I wasn't really happy there; I was probably too bored. At the age of eleven I'd decided, in my mind, that I wanted to be an artist, but the meaning of the word 'artist' to me then was very vague – the man who made Christmas cards was an artist, the man who painted posters was an artist, the man who just did lettering for posters was an artist. Anyone was an artist who in his job had to pick up a brush and paint something.

It's difficult to say *why* I decided I wanted to be an artist. Obviously, I had some facility, more than other people, but sometimes facility comes because one is more interested in looking at things, examining them, and making a representation of them, more interested in the visual world, than other people are. When I was eleven, the only art you saw in a town like Bradford was the art of painting posters and signs. This was how one made one's living as an artist, I thought. The idea of an artist just spending his time painting pictures, for himself, didn't really occur to me. Of course I knew there were paintings you saw in books and in galleries, but I thought they were done in the evenings, when the artists had finished painting the signs or the Christmas cards or whatever they made their living from.

My father had a slight interest in art. He didn't know much about pictures, but he had attended evening classes at the art school in Bradford in the twenties and thirties, which meant he'd been interested enough to try his hand at drawing and painting. When I was eleven, my father was painting old bicycles; just after the war you couldn't buy new bicycles – they were all exported – so my father used to buy old ones and paint them up to look like new. I used to watch him do it. The fascination of the brush dipping in the paint, putting it on, I love that, even now, I loved it then. There's something about it – I think anyone who makes pictures loves it, it is a marvellous thing to dip a brush into paint and make marks on anything, even on a bicycle, the feel of a thick brush full of paint coating something. Even now, I could spend the whole day painting a door just one flat colour.

My father obviously enjoyed doing that kind of thing. I remember in about 1950 he decided to modernize the house. He began by putting a whole sheet of hardboard flush over each of the panelled doors, and then he painted sunsets on the doors – sunsets that looked as if they were wood-veneer pictures. He painted all the doors like this, and I thought they were wonderful. He also used to paint posters a little bit. He was quite good at lettering. In those days, there were people who could do very quick hand-lettering; there was a demand

Self-Portrait with Blue Guitar, 1977. Oil on canvas, 60 × 72 (153 × 183).

for it. Posters advertising films were painted by hand. I would go up and look to see how they were done. You could still see the brush marks. People also did little signs for restaurants and cafés. To me this was the work of a real artist.

At Bradford Grammar School we had just an hour and a half of art classes a week in the first year; after that you went in for either classics or science or modern languages and you did *not* study art. I thought that was terrible. You could only study it if you were in the bottom form and did a general course. So I said Well, I'll be in the general form, if you don't mind. It was quite easy to arrange, because if you did less work you were automatically put in that section. I remember the mathematics teacher used to have some little cacti on the window sill; I always thought I never needed to listen in those classes, and I used to just sit at the back and secretly draw the cacti. Then they told me off for not doing much work, and the headmaster said Why are you so lazy? You got a scholarship. When I pointed out that I wanted to do art, they told me There's plenty of time for that *later*.

I think it's a very bad thing people aren't made to study art. Whole generations of people in England went to schools where they had no visual education, and you can see the results all around us. Visual education is treated as if it's quite unimportant, but it's of vast importance because the things we see around us affect us all our lives. After the first year at the Grammar School you didn't do any more art until you got into the sixth form, when you did art appreciation, and I think that's a little bit late. Even if one isn't going to be an artist – of course, most people aren't going to be artists – art training sharpens the visual sense, and if people's visual sense is sharp you get beautiful things around you, whereas if it's not they don't care about their surroundings. It makes a vast difference to a city, to a country.

The art master used to be encouraging, and so did a man who taught English. Once we were supposed to write an essay on some subject, and I hadn't done it because I'd spent all my time making a collage self portrait for the art class. So when he said Where is your essay? Can I read it out? I had the collage with me for the art class and – I was, I suppose, a cheeky schoolboy – I said I haven't done the essay, but I've done this. And he looked at the collage, and he said Oh, it's marvellous. I was so taken aback because I expected him to say You terrible person.

At the school there was an art society which met in the evenings, and I used to go to that. The school magazine always had a report about the various societies, and I remember in my very first term the report on the art society said 'Hockney D. provided light relief.' I was about eleven, and I didn't know what 'light relief' was; it sounded like sculpture to me – I thought maybe that was what I'd been doing there.

I wanted to go to the junior art school, attached to Bradford School of Art, when I was fourteen, but the scholarship people wouldn't let me leave the Grammar School and the headmaster said It's silly, and you need this education. I hated them for making me stay. I left immediately I was sixteen. My parents were a bit reluctant to let me start at art school then, because when my brothers left school they had gone out to work. Their worries were only financial, that's all. I said Oh, it's essential to go to art school; to be an artist you have to be trained. But my mother said Well, why don't you go and try to get a job in a commercial art studio in Leeds? She sent some little drawings up to London, to the National Council for Design, or something, and she got a letter back saying No, they were no good at all. And so I said – I was quite pleased – It means, you see, you have to go to art school to learn. But I did try to get a job. I made up a little portfolio; I did some lettering and other things I thought commercial artists would do. I took it round some studios in Leeds and finally one of them said Well, we could give you a job, but you would be better off going to art school. And I said Oh, I know. Then they told me they might give me a job, but I said No, maybe I'll go to art school, I'll take your advice. I went back home and told my mother they said I must go to art school even if it's just for a year. She seemed convinced, so I started at the School of Art in Bradford.

When I started at the art school, they said Well, you should do commercial art. At first I was ready to do anything they suggested, I was so pleased to get in there, but after I'd been there three or four weeks I realized that really I'd be better off saying I wanted to do painting because all you did then was drawing and painting, especially from life. Most of the students on this course said they wanted to be teachers – it was regarded as the teacher training course. I told them I wanted to change to the painting course. Ah, you want to be a teacher. No, no, I said, an artist – it seemed to me to be giving in already if you said 'teacher'. I thought you should teach only after you had practised the art for a while on your own; otherwise you wouldn't know what to teach. They tried again to put me off; they said Do you have a private income? I said What's that? I don't know what a private income is. They said You'll never make a living as a painter. Most people never will but, again, it seems a rotten thing to say to somebody of sixteen, if he's keen. *I* would never say that to somebody of sixteen. Anyway, I wasn't put off, and I changed to the course for the National Diploma in Design. You studied a main subject and a subsidiary subject for two years; my main subject was painting, and my subsidiary was lithography. Then the last two years you could specialize in one subject which for me was painting. It meant that for four years all you did was draw and paint, mostly from life; for two days a week you did life painting, two days a week what they called figure composition, which had to be realistic, from life, and one day a week drawing. During the first two years one day a week was devoted either to perspective or anatomy. The training was completely academic. In the last year a lady gave a few lectures on art history and for your final examination you had to write an essay on an artist or a school of painting.

I was interested in everything at first. I was an innocent little boy of sixteen and I believed everything they told me, everything. If they said You have to study perspective, I'd study perspective; if they told me to study anatomy, I'd study anatomy. It was thrilling, after being at the Grammar School, to be at a school where I knew I would enjoy everything they asked me to do. I loved it all and I used to spend twelve hours a day in the art school. For four years I spent twelve hours there every day. There were classes from nine-thirty to twelve-thirty, from two to four-thirty and from five to seven; then there were night-classes from seven to nine, for older people coming in from the outside. If you were a full-time student you could stay for those as well; they always had a model, so I just stayed and drew all the time right through to nine o'clock.

What you look at is important when you are that young. Most of the art I saw was at the art school. In those days there were very few art books and the library was very small; I can remember the arrival of the first big art books with colour pictures, the Skira books from Switzerland. I pored over them – they were books on nineteenth-century French painting, the impressionists. I didn't make my first trip to London until I was nineteen, which meant the only *real* paintings I'd ever seen were in Bradford, Leeds, Manchester and York. The Leeds Art Gallery had quite good pictures. In those days they had the great big Rembrandt equestrian picture which is now in the National Gallery, and they had one or two French pictures, and Flemish ones. The only contemporary art we saw was English. In my last year, when we'd already done a lot of drawing, I realized how academic the art school was and I began to think, the whole problem is, I don't know anything about modern art. They liked Sickert; Sickert was the great god and the whole style of painting in that art school – and in every other art school in England – was a cross between Sickert and the Euston Road School. By the time I was leaving, I'd started having doubts as to what was valuable: had I really done anything valuable? Had the time been wasted? Well, of course, it's really a bit silly asking a twenty-year-old whether he has wasted his time or not. Anyway, these doubts were raised in me because I'd become more aware of contemporary art.

Portrait of My Father is almost the first oil painting I ever did. It was painted at home on Saturday afternoons when my father had finished work. In the last two summers I was at

Bradford I used to paint out of doors. I did a number of little pictures of semi-detached houses, Bradford suburbs. I put all the paints on a little cart made from a pram, wheeled it out and painted on the spot. And they loved my pictures at the art school; they thought they were quite clever. But *Portrait of My Father* was *sold*. I sent that and another picture of the street where I lived in Bradford to an exhibition in Leeds, in 1954 I think, the Yorkshire Artists Exhibition, which was held every two years in the Leeds Art Gallery for local Yorkshire artists. It was a big event. All the staff of the art school sent pictures and most of the paintings were made up of the graduate fellows there, who were regarded as highly professional. Most of the other pictures were by teachers of local art schools. When I sent these two pictures, I didn't even bother putting a price on them; I thought, no one will buy them anyway.

I remember going to the opening on a Saturday afternoon. They had free sandwiches and tea and I thought it was a great event, an enormous event. A man at the opening saw *Portrait of My Father*, found out that a young boy had done it, and offered me ten pounds for it; I was amazed! It was a great deal of money and as my father had bought the canvas I thought, it's really *his* painting, it's his canvas – I'd just done the marks on it. So I phoned him up and said There's a man who'd like to buy this picture, can I sell it? And he said Ooh, yes. He thought it was because it was of *him*, you see, and he said You can do another. So I said Yes, all right. I had to buy drinks for everybody at the art school the next Monday. That probably cost a pound. The idea of spending a whole pound in a pub seemed absurd, but with the rest of the ten pounds I got some more canvas and painted some more pictures and then I exhibited them, in local exhibitions in Bradford and Leeds, mostly. The paintings are mostly oils. Doing an oil painting was considered advanced, and a painting three feet by four feet was considered then to be a major canvas you were going to be slaving away at for a long time.

When I painted *Portrait of My Father*, my father, who'd bought the canvas, set up the easel and then set the chair up for himself, and he set mirrors round so he could watch the progress of the painting and give a commentary. And he would say Ooh, that's too muddy, is that for my cheek? No, no, it's not that colour. I had this commentary all the time, and I'd say Oh, no, you're wrong, this is how you have to do it, this is how they paint at the art school, and I carried on. You aimed at likeness, but what you were really concerned about were tonal values – tone – making sure you'd got the right tone. This meant you ignored colour. Colour was not a subject of painting in the art school.

After leaving the art school in 1957 I had to do national service, and I objected to doing it. I thought of myself as a pacifist then, and I went and worked for one year at the hospital in Bradford. Then I moved. I rented a cottage at St Leonard's-on-Sea in Sussex, and worked at a hospital in Hastings. For two years I did very little work.

I read Proust for eighteen months, which is probably another reason I didn't do any work. I *made* myself read it because at first it was much too difficult. I'd never been abroad, but I'd been told it was one of the great works of art of the twentieth century. I'd read from an early age, but mostly English. So long as it was about England, I had some sense of what it was about. Dickens I'd read and you had some sense of what it was, but Proust was different. I remember asparagus was mentioned in it; I had no idea what asparagus was. I've since read it again, and I realize I couldn't have got much from reading it the first time.

In 1957 I had applied to the Royal College of Art and the Slade with life drawings, life paintings and figure compositions, paintings I'd done at the art school and at home during holidays. Anybody who'd studied painting in art school in those days would then apply either to the Royal College or the Slade or the Royal Academy, which were post-graduate schools; what one learned at art school wasn't sufficient. I was really glad to get back to art school and I was determined to work hard again. I'd been accepted in the Royal College painting department. Ron Kitaj was in the same year, and Allen Jones, Derek Boshier, Peter Phillips.

Soon after I started at the Royal College, the kind of paintings I did changed: in those two years of doing hospital work, although I hadn't done any painting, naturally I'd been thinking about it. In my last year at Bradford School of Art I made three or four trips to London and looked at things in the Tate Gallery, the National Gallery. I was young, and all young people are more interested in the art of their immediate time – old Michelangelo, you know, you don't quite see it and understand it.

It was only then, in a way, I'd begun to discover Picasso. In the fifties in England, there was still, especially if you lived in the provinces, a mile of philistinism about Picasso. It's disappeared now. For instance, Alfred Munnings, the horse painter, was always referring to Picasso as an awful, terrible artist, and things like that. I remember reading once that Picasso had said Who is this Sir Munnings? At the time I realized people were just being philistine and the art was obviously much better than anything they were doing. Yet it was quite difficult sorting it out, and so when I started at the Royal College of Art I honestly did not know what to do. I realized it was no good going on painting as I had been; I felt I wanted to do something else. I didn't even have any strong preferences about the modern art I had seen. I was very open. I'd become quite a lover of Picasso though. It'd begun to have quite an effect. I think the very first Picassos I'd liked were from the late thirties: *Weeping Woman*, I remember, was a picture I began to really admire. It was these thirties Picasso paintings and *Guernica* that, I began to realize, I had to take notice of myself. They were great significant pictures and if you were studying painting you had to take notice of them.

Immediately after I started at the Royal College, I realized that there were two groups of students there: a traditional group who simply carried on as they had done in art school, doing still life, life painting and figure compositions; and then what I thought of as the more adventurous lively students, the brightest ones, who were more involved in the art of their time. They were doing big abstract expressionist paintings on hardboard.

The first student I got to know there was Ron Kitaj. We got on immediately. Also, his painting straightaway fascinated me. I could tell he knew more about painting than anybody else. He's about four years older than I am, which when you're twenty-two is a lot of difference, in experience anyway. He was a much more serious student than anybody else there. He has a marvellous dry humour that really appeals, but in those days he was much grimmer than he is now, and he was a rather formidable person. He used to put up a kind of front against people as though he couldn't tolerate fools. I got on with him because we had a few things in common. Literature we would talk about; he was interested in Orwell, and I remember talking to him about *The Road to Wigan Pier* which I knew very well as a book from a long time ago. It was written in the year I was born, and my father was always mentioning it; he'd say It was written in the year you were born, and this is what it was like. Ron was a great influence on me, far more than any other factor; not just stylistically – he was a great influence stylistically on a lot of people, and certainly on me – but in his seriousness too. Painting was something that you were studying seriously. A lot of people thought art students were serious in that way, but they weren't; they just gassed around, and I always thought that was silly. The painters teaching at the College left you fairly free, as long as you did drawing, because in those days that was still compulsory – which was fine with me. I'd always liked drawing a figure. Some people hate it, they don't want to do it; I'd always liked it, partly because I've always been able to do it; but I worked at it. Everybody else was doing big abstract expressionist pictures. And I thought, well, that's what you've got to do.

In 1956 there'd been a big exhibition at the Tate of American abstract expressionist painting, and then Bryan Robertson had done shows at the Whitechapel of Pollock and in 1961 Rothko. And this was the latest thing. This was painting that had been done just two or three years before in America. Young students had realized that American painting was more interesting than French painting. The idea of French painting disappeared really, and

American abstract expressionism was the great influence. So I tried my hand at it, I did a few pictures, about twenty on three feet by four feet pieces of hardboard that were based on a kind of mixture of Alan Davie cum Jackson Pollock cum Roger Hilton. And I did them for a while, and then I couldn't. It was too barren for me.

Meanwhile, I was drawing all the time. The one student I kept talking to a lot was Ron Kitaj. Ron was slowly doing these strange pictures, and I talked to him about them and about my work. And I said Well, I don't know, it seems pointless doing it. I'd talk to him about my interests; I was a keen vegetarian then, and interested in politics a bit, and he'd say to me Why don't you paint those subjects? And I thought, it's quite right; that's what I'm complaining about, I'm not doing anything that's from me. So that was the way I broke it. I began to paint those subjects. But I still hadn't the nerve to paint figure pictures; the idea of figure pictures was considered really anti-modern, so my solution was to begin using words. I started writing on the pictures. And when you put a word on a painting, it has a similar effect in a way to a figure; it's a little bit of human thing that you immediately read; it's not just paint. The idea came because I didn't have the courage to paint a real figure, so I thought, I have to make it clear, so I'll write 'Gandhi' on this picture about Gandhi. I can remember people coming round and saying That's ridiculous, writing on pictures, you know, it's mad what you're doing. And I thought, well, it's better; I feel better; you feel as if something's coming out. And then Ron said Yes, that's much more interesting.

I wrote a little piece the other day for a catalogue of a show in Los Angeles, just a very short thing about painting (I'm rather against painters making big polemical statements in catalogues. I've never done it myself. There are a few vague ones, that's all. From experience I know they become things that are very heavily quoted). I said I felt I was quite a traditional artist and painter in the sense that to me paintings should have content. I said my paintings have content, always a subject and a little bit of form. And I was traditional in the sense that I felt you should have a balance between these two to make a really good painting. If you didn't (I didn't add it but inferred it), the painting would become boring, in the sense that English Victorian painting is – it can be very charming and it wasn't as bad as people think, but the weakness of it is that its real emphasis is on content as opposed to form. The weakness of a lot of paintings today, of the last ten years, is just the reverse: that their emphasis has been totally on form and not on content. It seems to me that really great pictures – and I'm interested in making *pictures* – must achieve a balance. Take Rembrandt, or anybody we admire: his achievement is the balance between content and form; it's not just form.

What I'm talking about of course is a permanent problem in painting, which probably will never be solved in theory. For instance, look at Piero della Francesca's wonderful pictures that are marvellous and exciting to look at, that delight you. I would think anybody who likes painting at all would like a Piero della Francesca; I couldn't imagine anybody thinking they were awful in any way. Each picture, as far as I know, has a very definite subject; I think every one is a Christian story, isn't it? Yet our delight in the pictures is in the way they're constructed; that's what makes them stand out, not the story. But the problem is that we don't know, we can never tell, how much the subject, in an old fashioned way, inspired these things. It's common knowledge that artists, certain artists, need a subject, that a subject can be inspiring. It's true in literature and it's true in painting. Some artists need subjects more than others, but you can play down the subject too much; there is an importance in it. In the 1960s the subject had been completely played down; abstraction had begun to dominate everything, and people firmly believed that this was the way painting had to go. There was no other way out, people thought. Even I felt that, and I still felt it even when I began to reject it in action; in theory I still couldn't reject it at all. I felt, well, I'm sure they're right, and I think I

felt that even as late as 1966. It was in 1965 I painted probably some of the most abstract pictures I'd done, influenced, I think, by American abstraction, what they called American cool abstraction. But of course what made it very different was that I was using abstraction as my subject, commenting on it – I felt the *need* to use it as a subject. I must admit I think the reason my paintings did have quite an appeal was that, first of all, people could write something about them. If you're writing about a Franz Kline painting, for instance, on the whole you're writing about formal values and gestures. You can always talk about formal values in a figurative picture, but there are other things. And that makes it easier for people to write about pictures. On the other hand, you have painters like Barnett Newman; if you compare Newman as a painter to, say, Degas, I think you can see that Newman is concerned more with ideas – obsessively so, because he's not as good an artist as Degas. He is more concerned with theory as well, though Degas was too – any good artist is, actually; you can't ignore it. But it's Degas's eye and attitudes that matter, the responses he got, the responses he in part *felt*. In Barnett Newman's work it isn't like that at all. I'm not praising one over another, we all know who is the better artist, I'm sure Barnett Newman wouldn't say he was as good as Degas. He loved Degas, actually, as I do. Once Newman came to one of the first shows I had in New York, and he said to me You know, I used to paint like this myself. And I said to him Do you mean I'm going to finish up painting blue stripes? and he laughed. He was a sweet man.

Editorial Note

Pictures by David Hockney is largely based on *David Hockney by David Hockney* which was first published in 1976. All textual matter comes from that book, which remains the standard work on the artist up to the year of its publication. Its detailed commentary on individual works still represents a unique source of information about the artist's thoughts and artistic processes. But it has always been Hockney's desire to make available an album of his most representative pictures, unencumbered by any commentary; as he stated: 'It is very good advice to believe only what an artist does, rather than what he says about his work.' This book, then, contains a representative selection of what Hockney has done up to 1979, in his painting, drawing, graphic work and, more recently, in the spectacular series, *Paper Pools*, made with coloured and pressed paper pulp.

The title for this book was suggested by Hockney himself, who has always insisted: 'I'm interested in making *pictures*.' The thematic arrangement, however, was made by me despite Hockney's slight reluctance for fear he might be thought to work in series of themes or subjects. A look at the dates of the works, however, will show that this is not the case. On the other hand, there is no doubt that he often returns to the same themes and subjects, as any artist or writer does, which not only validates a thematic arrangement but allows the viewer a fascinating glimpse of the inventive and varied ways in which the same themes are treated over time.

Grateful acknowledgment for their great help in the preparation of this book is due to: John Kasmin and Ruth Kelsey of Knoedler Kasmin Ltd, Paul Hockney and Deborah Rogers.

In the captions measurements are given first in inches then in centimetres, height before width.

Nikos Stangos

Objects and still lifes

The tea packets piled up with the cans and tubes of paint and they were lying around all the time and I just thought, in a way it's like still-life painting for me. I thought there must be other things lying around, something I could use. This is as close to pop art as I ever came. But I didn't use it because I was interested in the design of the packet. These paintings were my first attempt to put recognizable images into paintings.

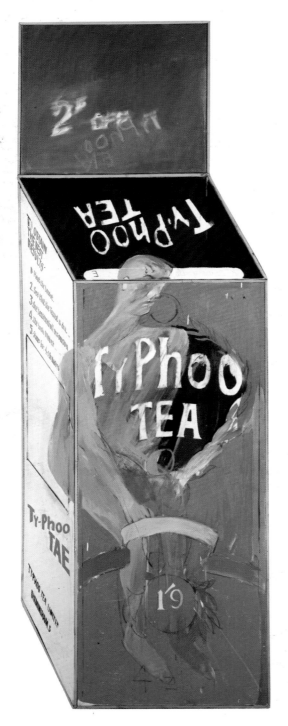

Tea Painting in an Illusionistic Style, 1961.
Oil on canvas, 78 × 30 (198 × 76).

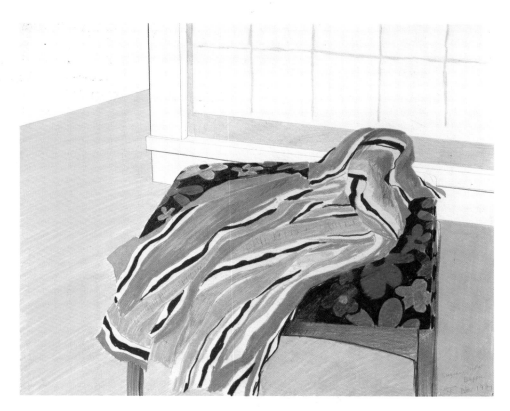

Chair and Shirt, 1972. Acrylic on canvas, 72 × 72 (183 × 183).

Suginoi Hotel, Beppu, 1971. Crayon, 14 × 17 (35·5 × 43).

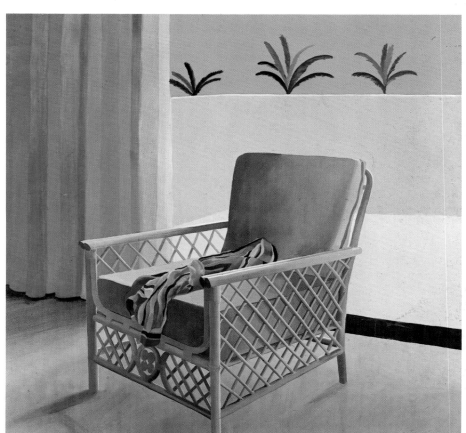

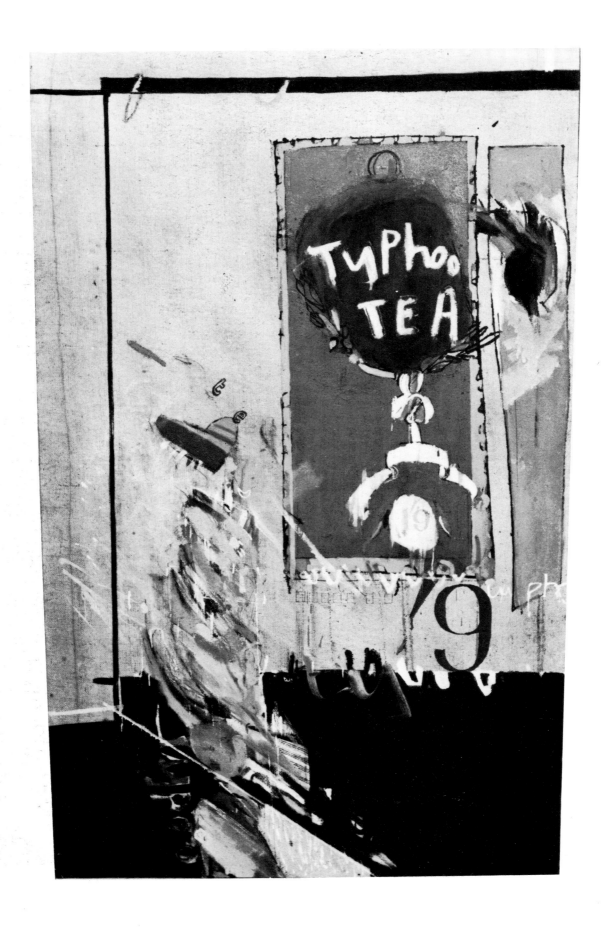

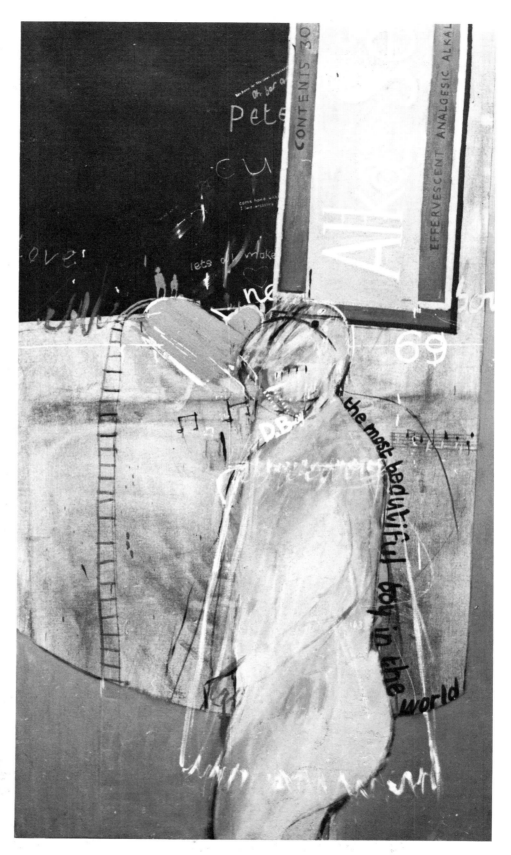

The Second Tea Painting, 1961. Oil on canvas, 61 × 36 (155 × 91).

The Most Beautiful Boy in the World, 1961. Oil on canvas, 70 × 39½ (178 × 100).

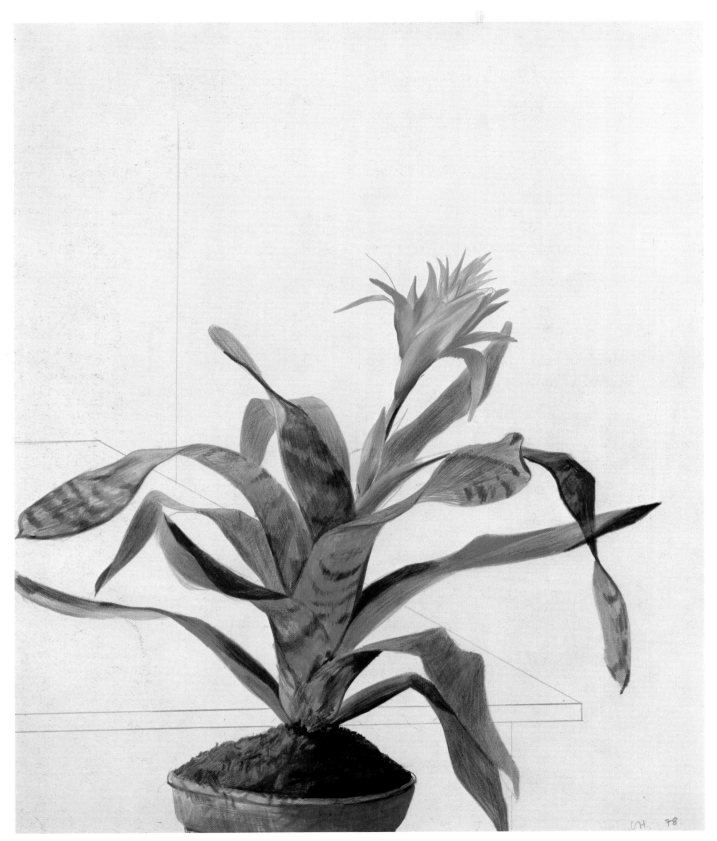

Flower, 1978. Crayon, 17 × 14 (43 × 35·5).

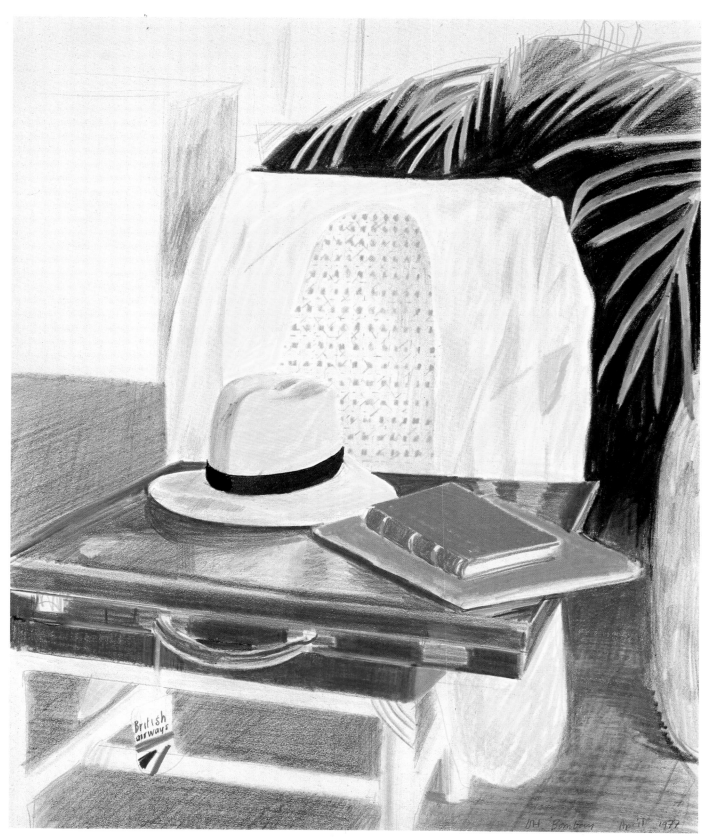

Still Life, Taj Hotel, 1977. Crayon, 17 × 14 (43 × 35·5).

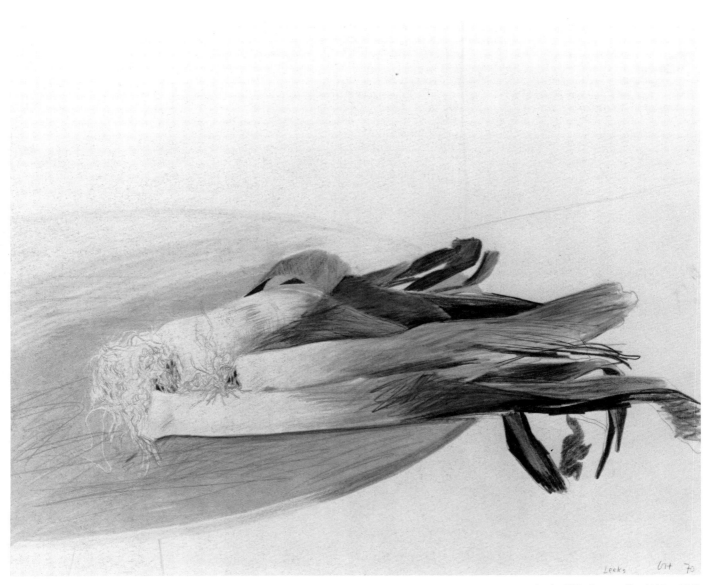

Leeks, 1970. Crayon, 17 × 14 (43 × 35·5).

Banana, 1970. Crayon, 17 × 14 (43 × 35·5).

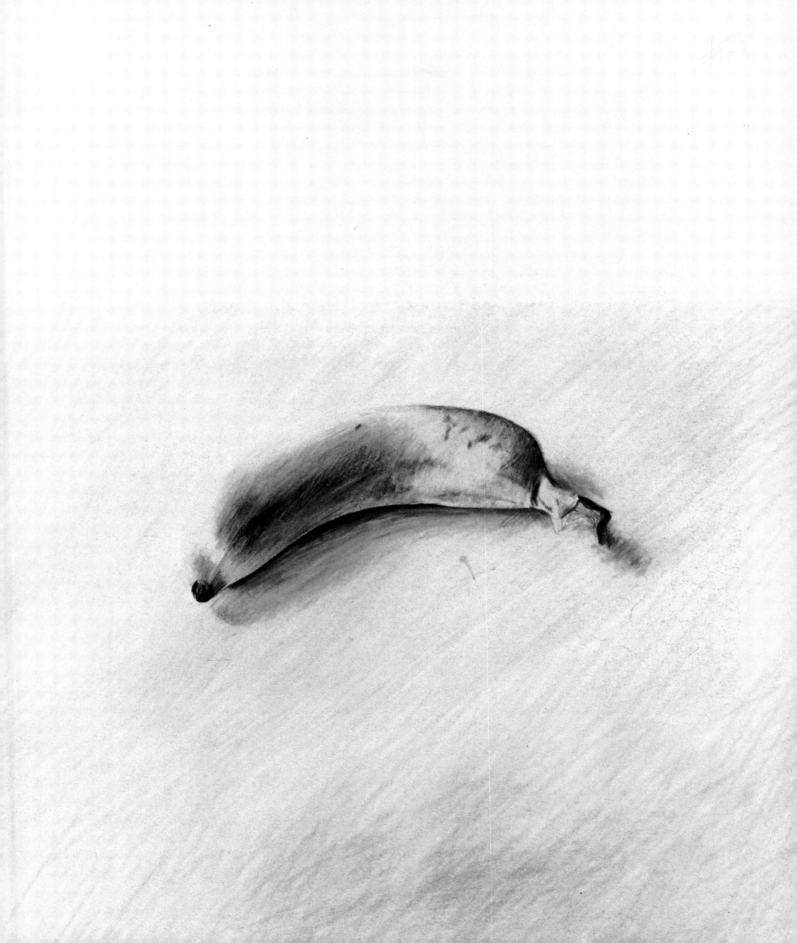

Egypt

I was interested in Egypt for several reasons, in the style, and in Egyptian painting, which in a sense is not one of the really interesting methods of painting, by any means. Egypt is fascinating, but its painting is too rigid to be really intriguing. The only thing that interested me about it was that the rules were so rigid that there's no individualism in the paintings; whoever painted them, it didn't matter; they had to obey the rules and so it all looks the same. And that interested me, the anonymous aspect of the artist, not the art. So I went to Egypt and I made a lot of drawings there. I drew everything. I went to Cairo, then Alexandria, and up to Luxor.

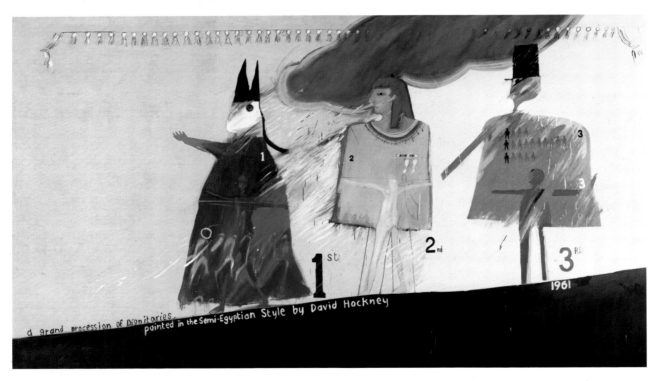

A Grand Procession of Dignitaries in the Semi-Egyptian Style, 1961. Oil on canvas, 84 × 144 (214 × 367).

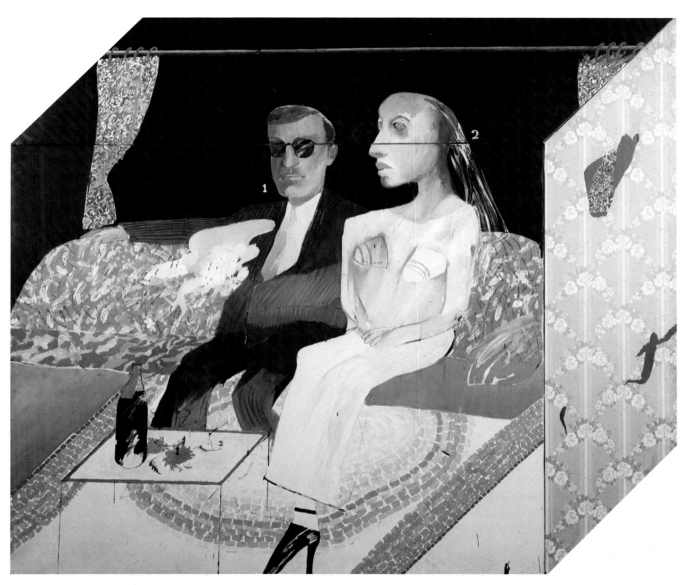

The Second Marriage, 1963. Oil on
canvas, 77¾ × 90 (198 × 229).

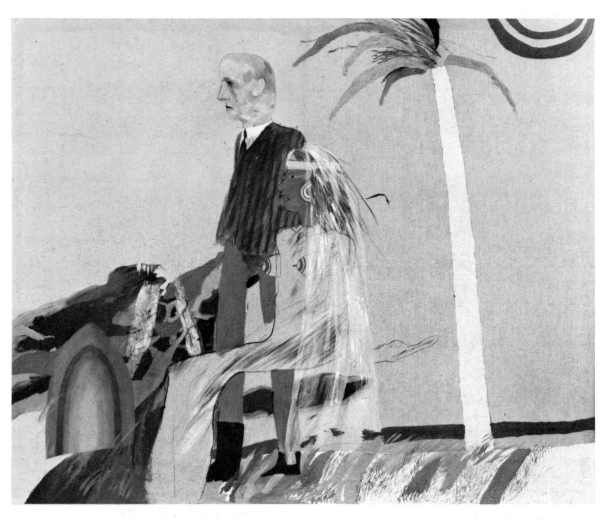

The First Marriage (A Marriage of Styles),
1962. Oil on canvas, 77 × 60 (183 × 153).

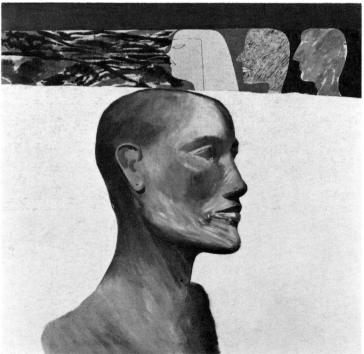

Four Heads (Egyptian), 1963. Oil on
canvas, 48 × 48 (122 × 122).

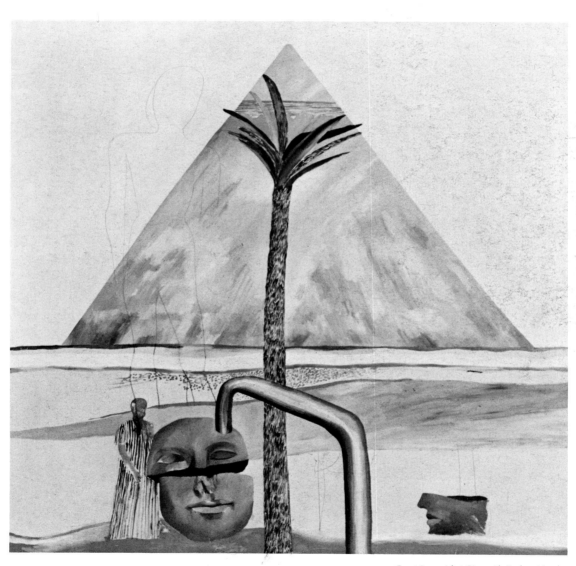

Great Pyramid at Giza with Broken Head from Thebes, 1963. Oil on canvas, 72 × 72 (183 × 183).

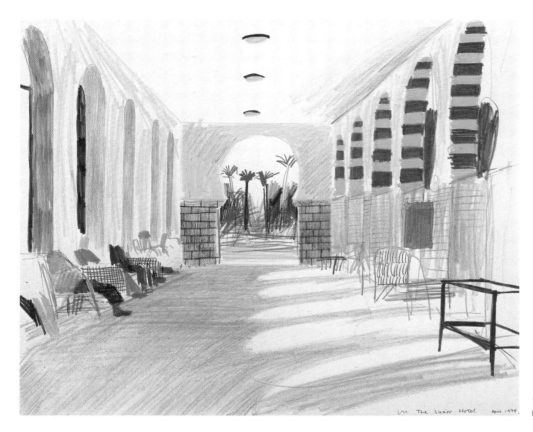

The Luxor Hotel, 1978. Crayon, 14 × 17 (35·5 × 43).

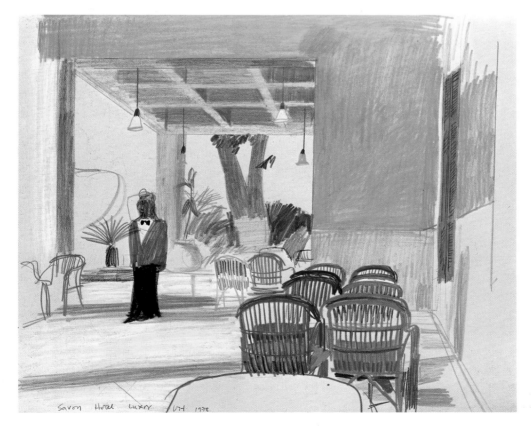

The Savoy Hotel, Luxor, 1978. Crayon, 14 × 17 (35·5 × 43).

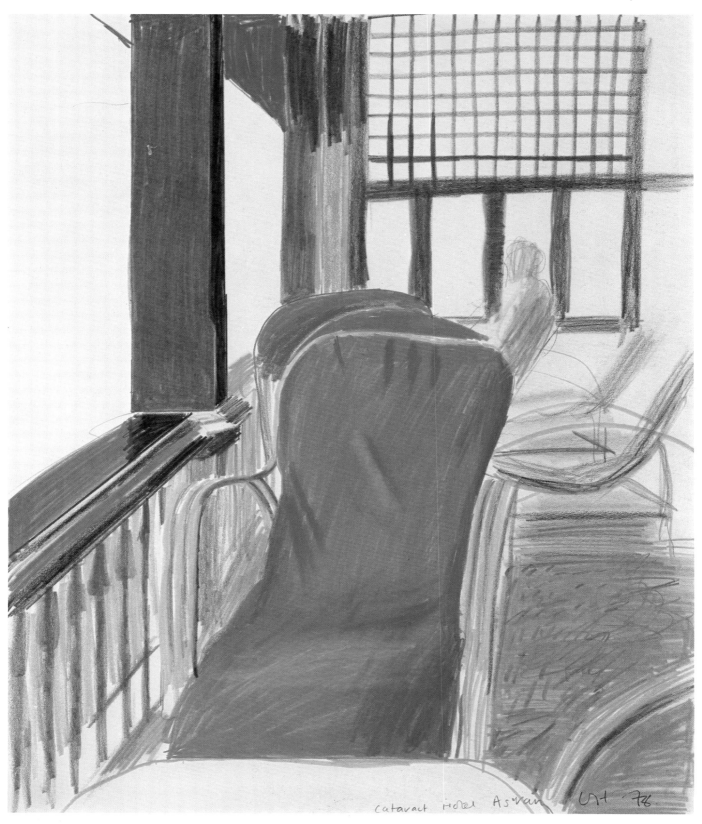

Cataract Hotel, Aswan, 1978. Crayon, 17 × 14 (43 × 35·5).

Curtains

The forms of the curtain first made me interested in it as a subject, and then it dawned on me that it could be even more interesting because it was *flat*. A curtain, after all, is exactly like a painting; you can take a painting off a stretcher, hang it up like a curtain; so a painter's curtain could be very real. All the philosophical things about flatness in a painting, if you go into it, are about reality, and if you cut out illusion then painting becomes completely 'real'. The idea of the curtains is the same thing.

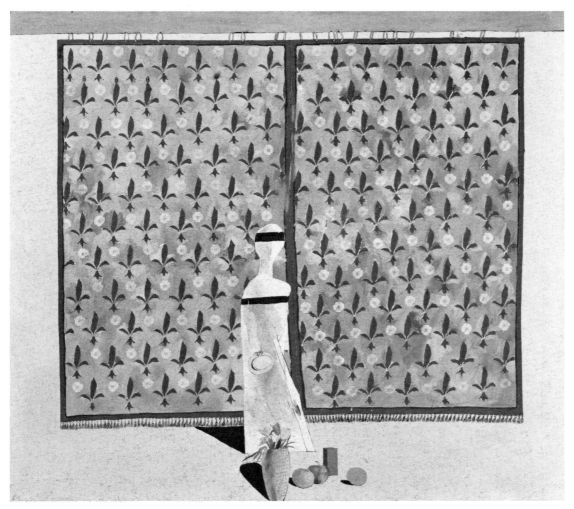

Still Life with Figure and Curtain, 1963. Oil on canvas, 78 × 84 (198 × 214).

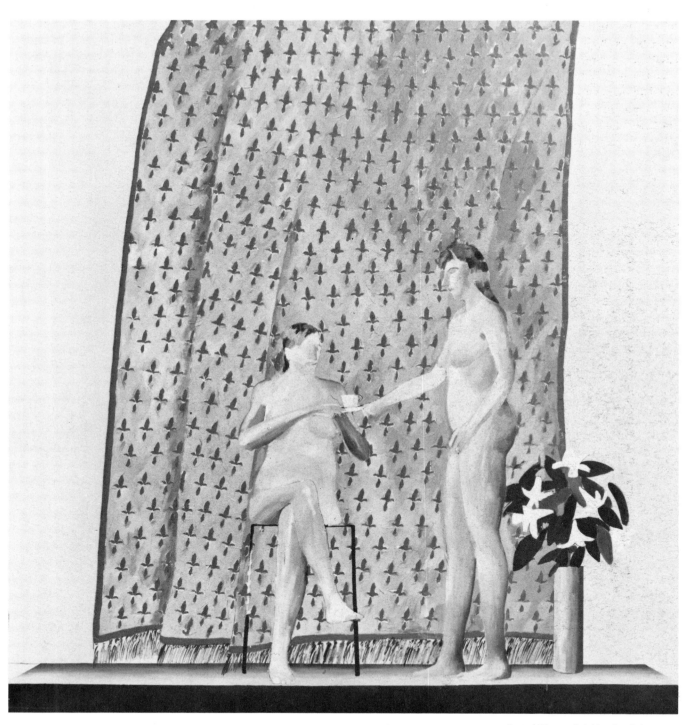

Seated Woman Drinking Tea, Being
Served by Standing Companion, 1963. Oil
on canvas, 78 × 84 (198 × 214).

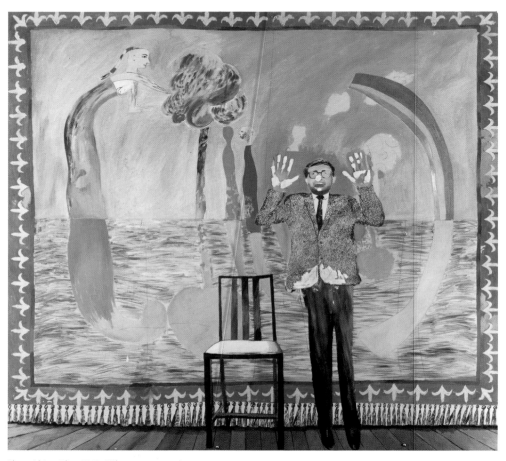

Play within a Play, 1963. Oil on canvas and plexiglass, 72 × 78 (183 × 198).

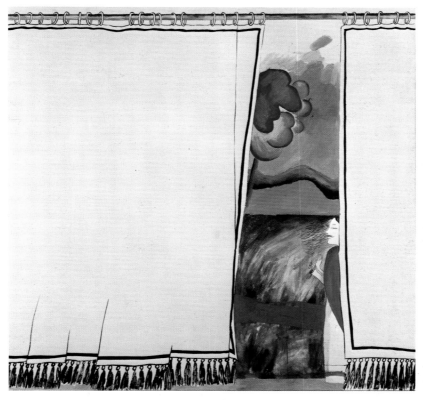

Closing Scene, 1963. Oil on canvas,
48 × 48 (122 × 122).

Showers

Americans take showers all the time. I knew that from experience and physique magazines. For an artist the interest of showers is obvious: the whole body is always in view and in movement, usually gracefully, as the bather is caressing his own body. There is also a three-hundred-year tradition of the bather as a subject in painting. Beverly Hills houses seemed full of showers of all shapes and sizes – with clear glass doors, with frosted glass doors, with transparent curtains, with semi-transparent curtains. They all seemed to me to have elements of luxury: pink fluffy carpets to step out on, close to the bedrooms.

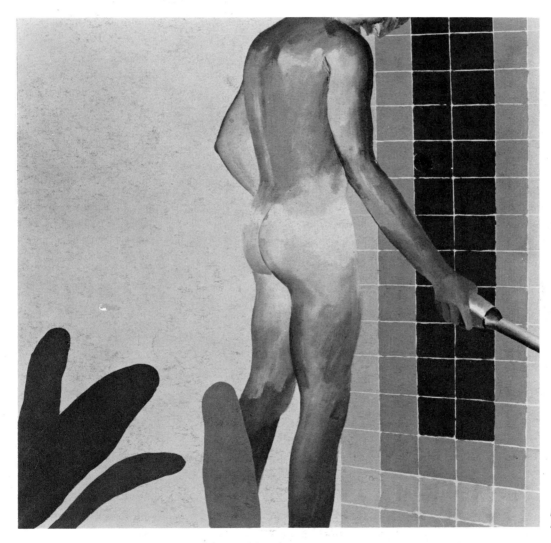

Boy About to Take a Shower, 1964.
Acrylic on canvas, 36 × 36 (91 × 91).

Man Taking Shower, 1965. Acrylic on canvas, 60 × 48 (153 × 122).

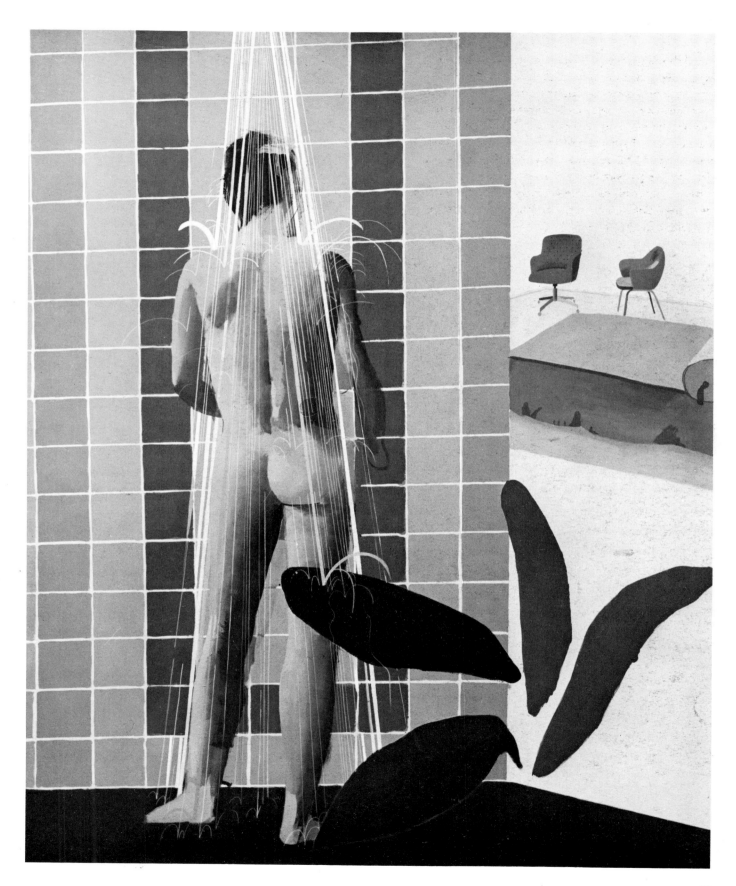

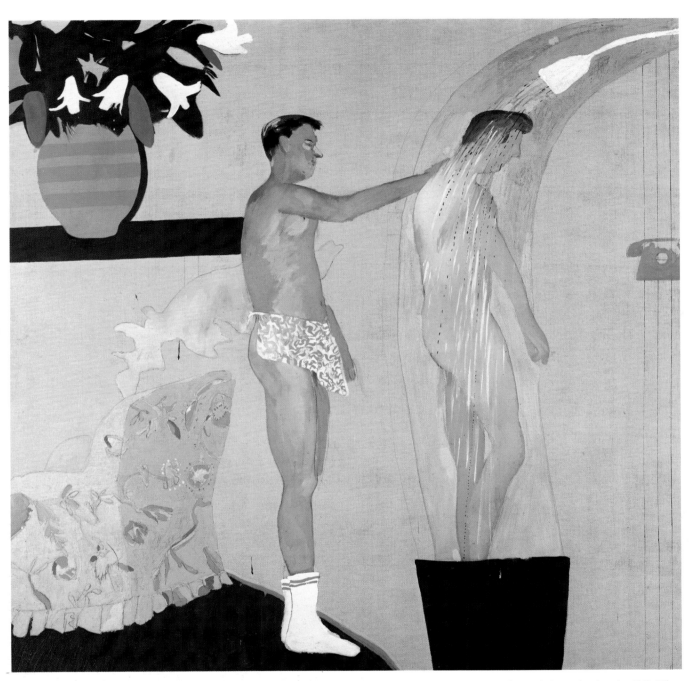

Domestic Scene, Los Angeles, 1963. Oil on canvas, 60 × 60 (153 × 153).

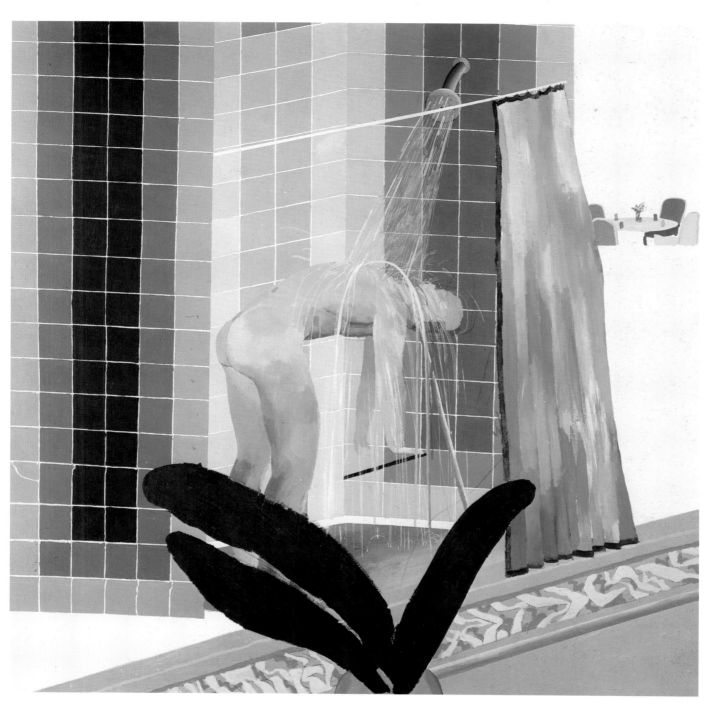

Man Taking Shower in Beverly Hills, 1964.
Acrylic on canvas, 65½ × 65½ (167 × 167).

California

When I got to Los Angeles I didn't know a soul. People in New York said You're
mad for going there if you don't know anybody and you can't drive. They said
At least go to San Francisco if you want to go West. And I said No, no, it's Los
Angeles I want to go to. I got into the motel, very thrilled; really, *really* thrilled,
more than in New York the first time. I was so excited. I think it was partly a
sexual fascination and attraction. I checked into this motel and walked on the
beach and I was looking for the town; couldn't see it. And I saw some lights
and I thought, that must be it. I walked two miles, and when I got there all it
was was a big gas station, so brightly lit I'd thought it was the city. After I'd
been there a couple of months, I went to visit some collectors. I'd never seen
houses like that. And the way they liked to show them off! They would show
you the pictures, the garden, the house. So then I painted a picture, *California
Art Collector*. The houses I had seen all had large comfortable chairs, fluffy
carpets, striped paintings and pre-Columbian or primitive sculptures and recent
(1964) three-dimensional work. As the climate and the openness of houses
(large glass windows, patios, etc.) reminded me of Italy, I borrowed a few
notions from Fra Angelico and Piero della Francesca.

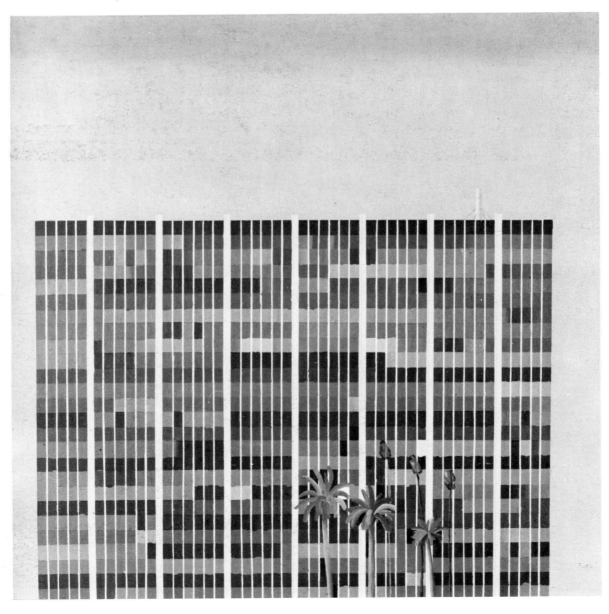

Savings and Loan Building,
1967. Acrylic on canvas,
48 × 48 (122 × 122).

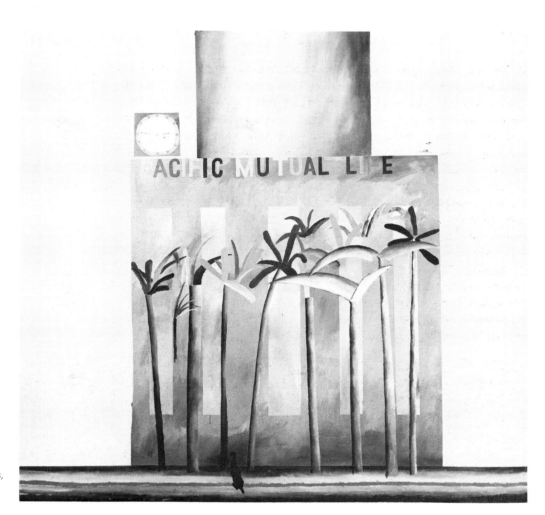

Building, Pershing Square, Los Angeles,
1964. Acrylic on canvas, 58 × 58
(147 × 147).

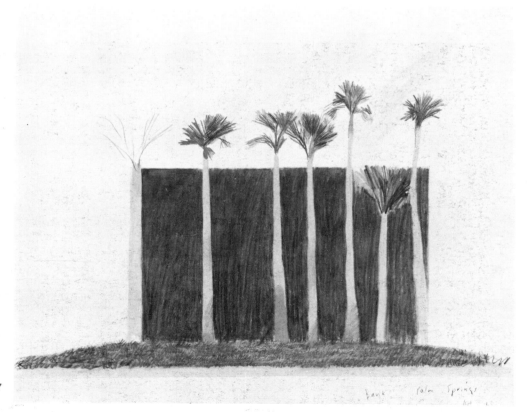

Bank, Palm Springs, 1968. Crayon, 14 × 17
(35·5 × 43).

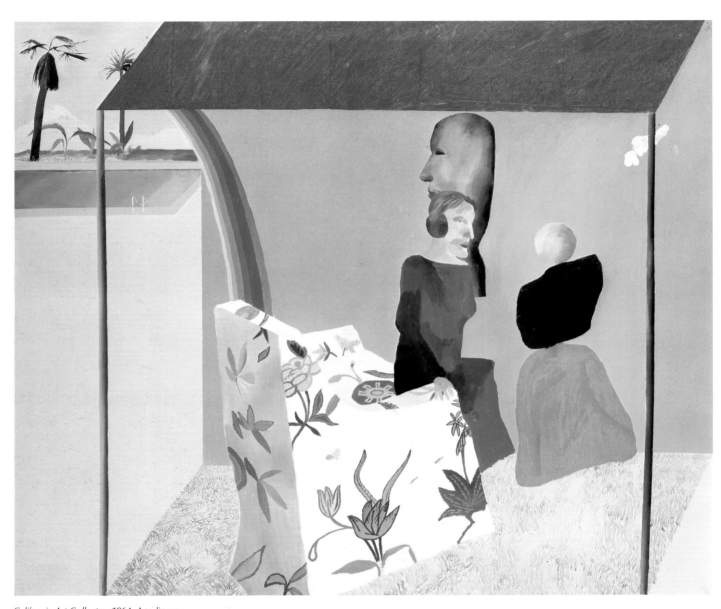

California Art Collector, 1964. Acrylic on
canvas, 60 × 72 (153 × 183).

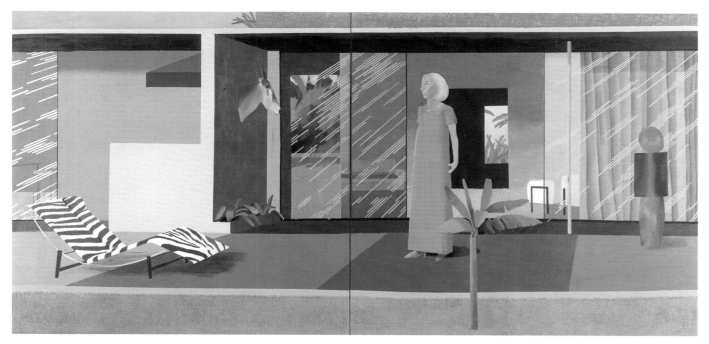

Beverly Hills Housewife, 1966. Acrylic
on canvas (diptych), 72 × 144
(183 × 366).

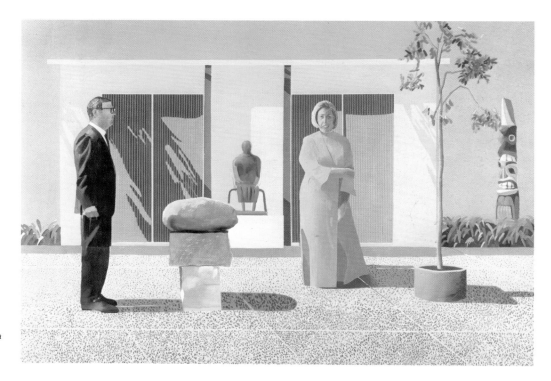

*American Collectors (Fred and Marcia
Weisman)*, 1968. Acrylic on canvas,
84 × 120 (214 × 305).

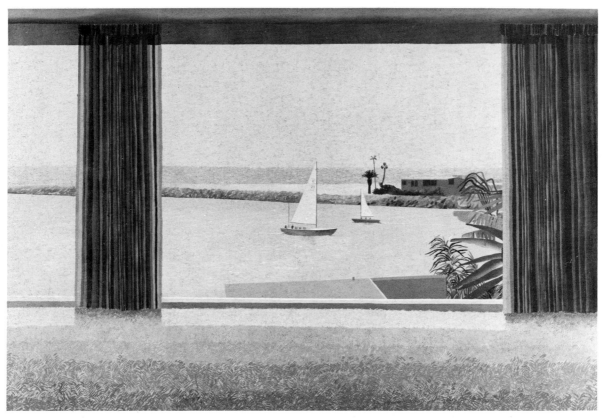

California Seascape, 1968. Acrylic on canvas, 84 × 120 (214 × 305).

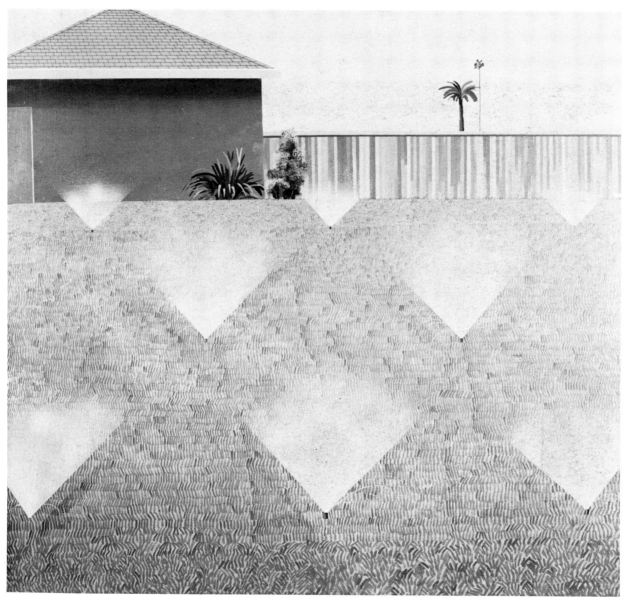

A Lawn Being Sprinkled, 1967. Acrylic on canvas, 60 × 60 (153 × 153).

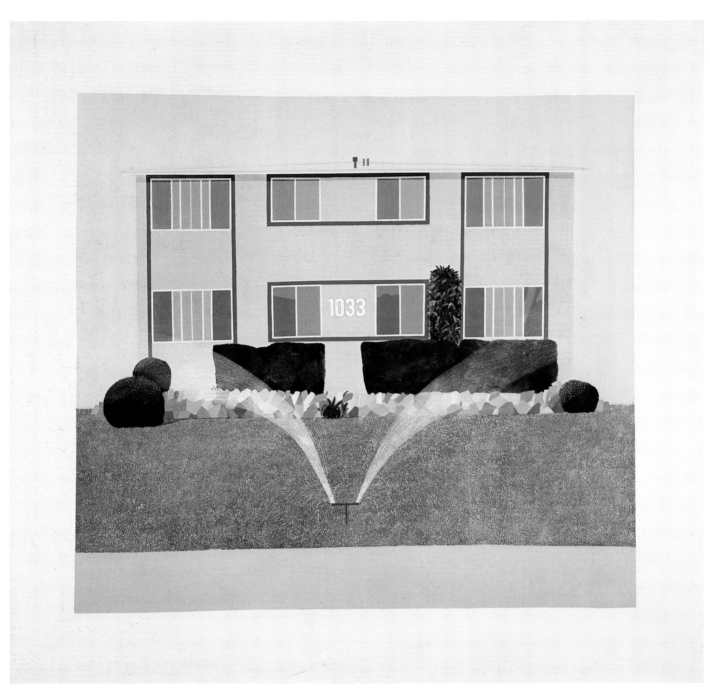

A Neat Lawn, 1967. Acrylic on canvas, 96 × 96 (244 × 244).

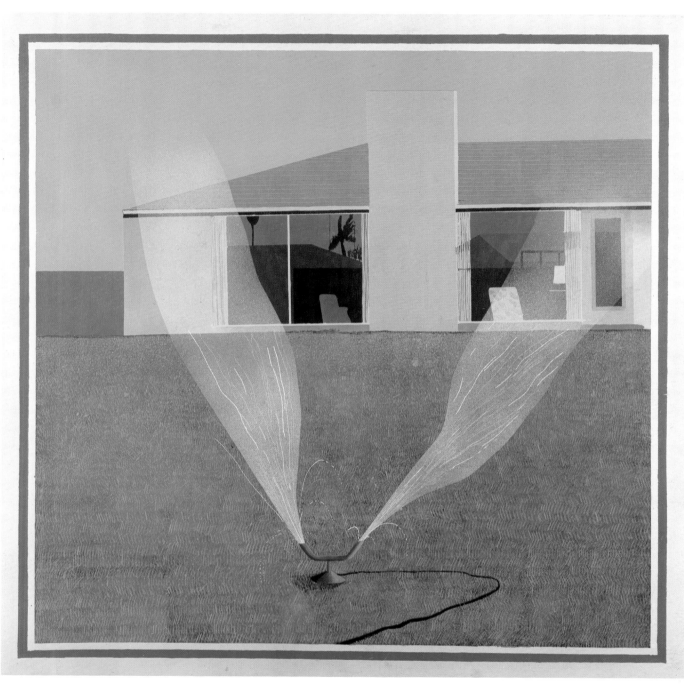

A Lawn Sprinkler, 1967. Acrylic on canvas, 48 × 48 (122 × 122).

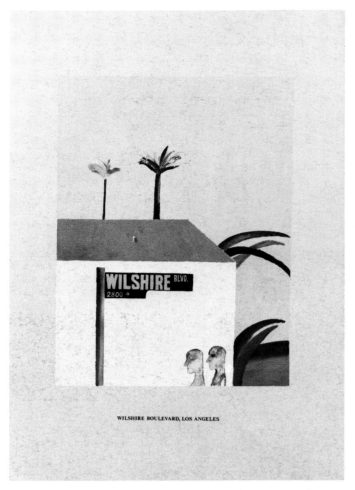

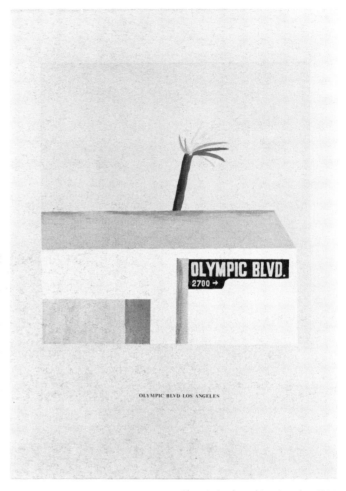

Wilshire Boulevard, Los Angeles, 1964.
Acrylic on canvas, 36 × 24 (91 × 61).

Olympic Boulevard, Los Angeles, 1964.
Acrylic on canvas, 36 × 24 (91 × 61).

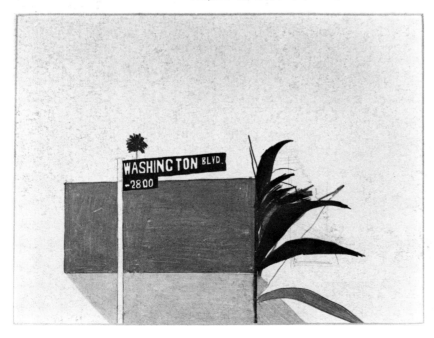

Washington Boulevard, 1964. Crayon,
13½ × 10½ (34·3 × 26·7).

Los Angeles, 1967. Crayon, 14 × 17 (35·5 × 43).

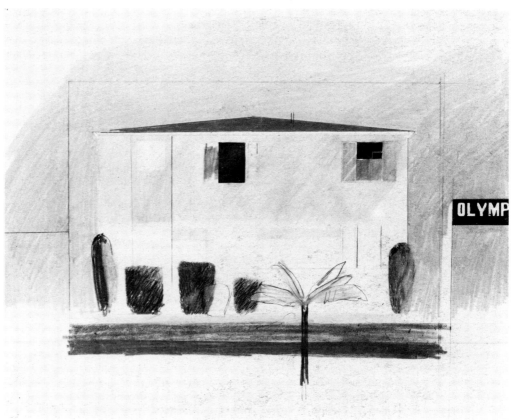

House near Olympic Boulevard, 1967. Crayon, 14½ × 16¾ (37 × 42·5).

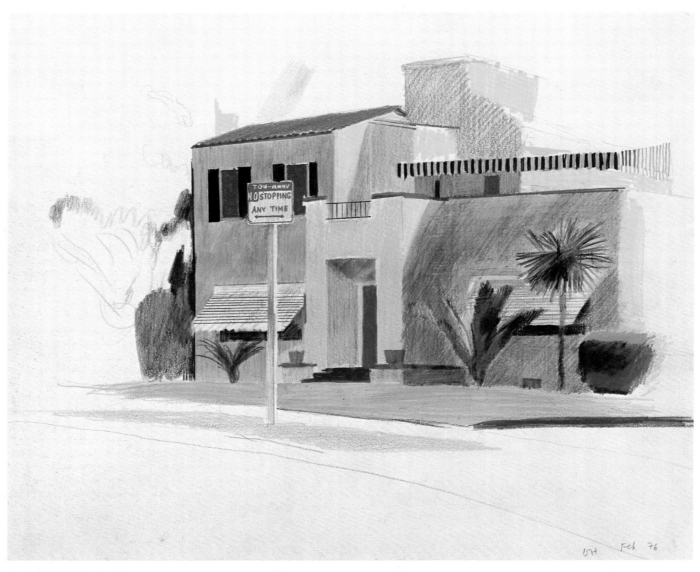

House Behind Château Marmont, 1976.
Crayon, 14 × 17 (35·5 × 43).

De Longpre Avenue, Hollywood, 1976.
Crayon, 17 × 14 (43 × 35·5).

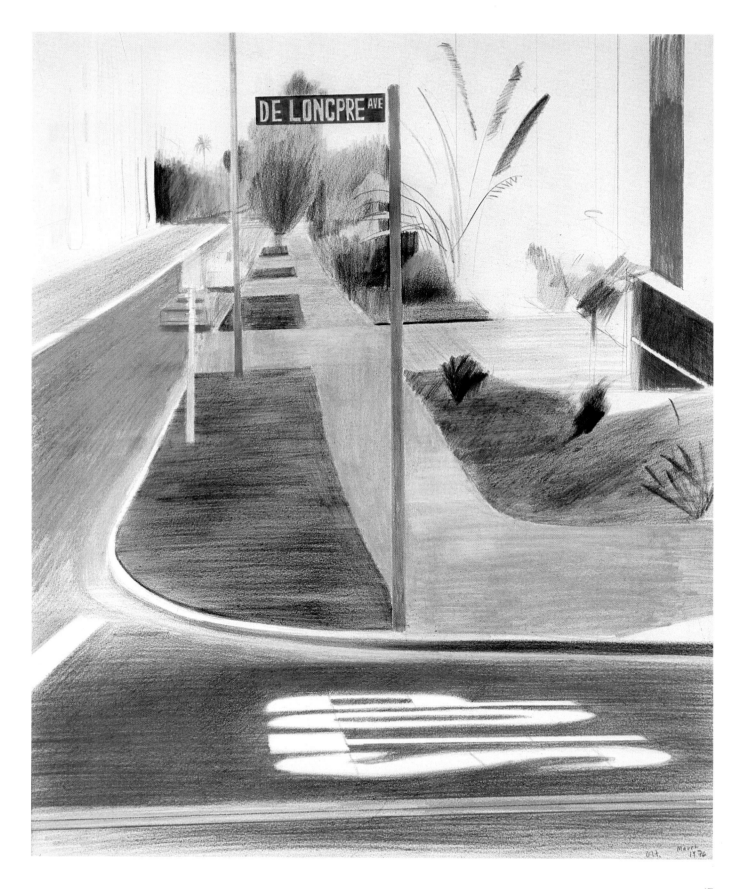

Pools and Water

The idea of painting moving water in a very slow and careful manner was (and still is) very appealing to me. In the swimming pool pictures, I had become interested in the more general problem of painting the water, finding a way to do it. It is an interesting formal problem; it is a formal problem to represent water, to describe water, because it can be anything – it can be any colour, it's movable, it has no set visual description. I just used my drawings for these paintings and my head invented. Later on, when I returned to more swimming pools – and they're painted in a different way – I took photographs of water. Water in swimming pools changes its look more than in any other form. The colour of a river is related to the sky it reflects, and the sea always seems to me to be the same colour and have the same dancing patterns. But the look of swimming-pool water is controllable – even its colour can be man-made – and its dancing rhythms reflect not only the sky but, because of its transparency, the depth of the water as well. So I had to use techniques to represent this (later I became more aware of the wetness of the surface). If the water surface is almost still and there is strong sun, then dancing lines with the colours of the spectrum appear everywhere. If the pool hasn't been used for a few minutes and there's no breeze, the look is of a single gradation of colour that follows the incline of the floor of the pool. Added to all this is the infinite variety of patterns of material that the pool can be made from.

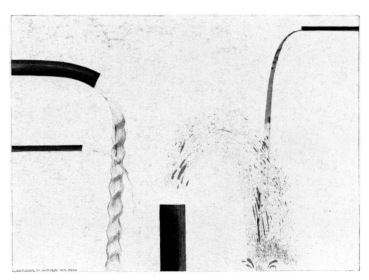

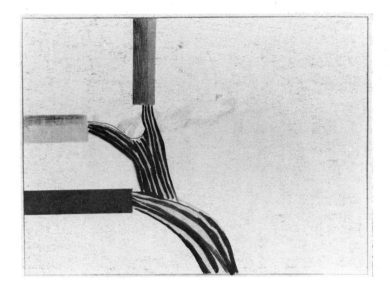

Water Entering Swimming Pool, Santa Monica, 1964. Crayon, 11 × 14 (27·5 × 35·5).

Water Pouring into Swimming Pool, Santa Monica, 1964. Lithograph on stone, in four colours, 20 × 26 (51 × 66).

Striped Water, 1965. Crayon, 13¾ × 16½ (35 × 42).

Different Kinds of Water Pouring into a Swimming Pool, Santa Monica, 1965. Acrylic on canvas, 72 × 60 (183 × 153).

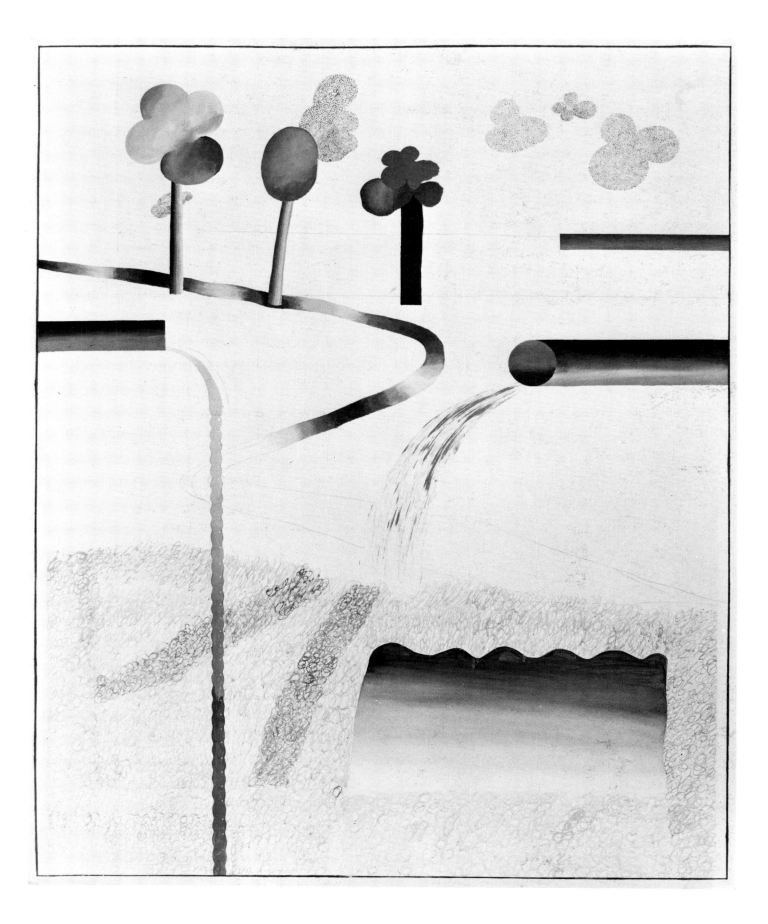

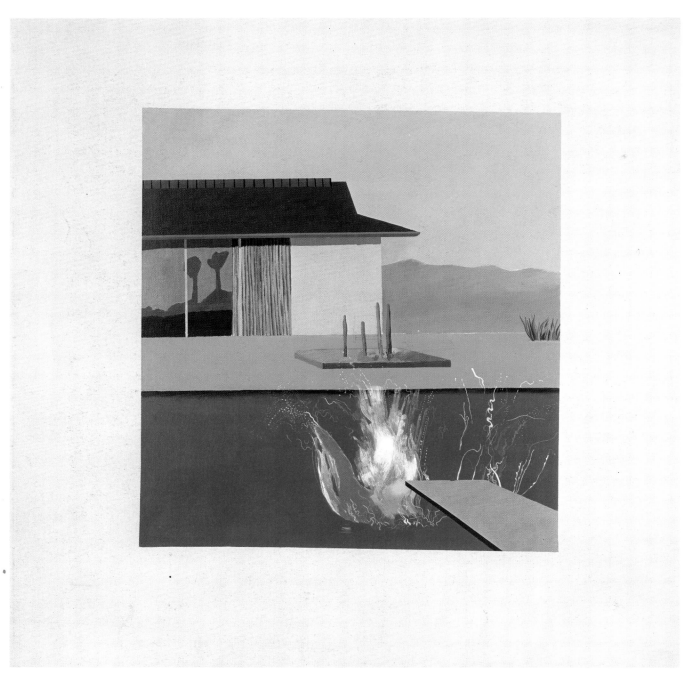

The Splash, 1966. Acrylic on canvas, 72 × 72 (183 × 183).

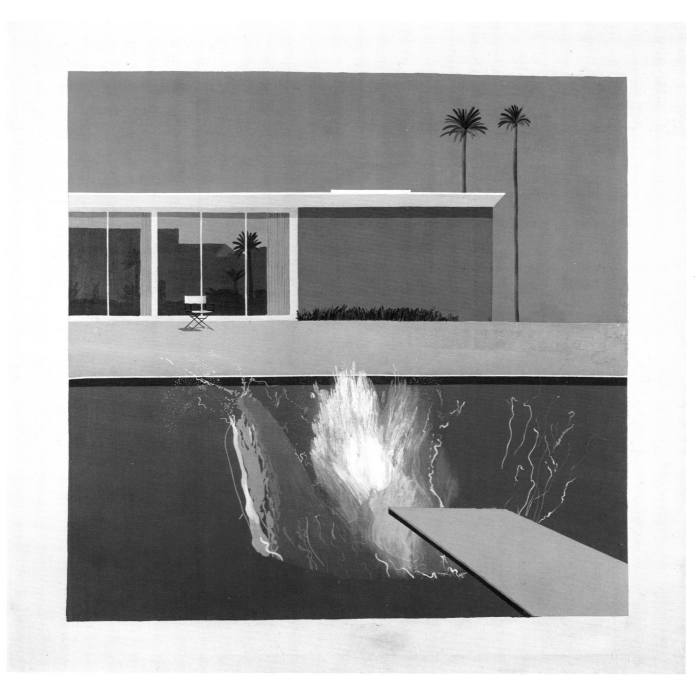

A Bigger Splash, 1967. Acrylic on canvas, 96 × 96 (244 × 244).

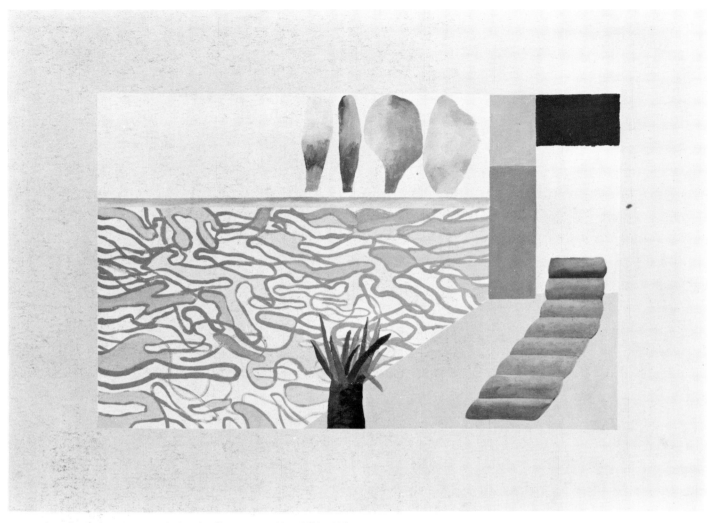

Picture of a Hollywood Swimming Pool, 1964. Acrylic on canvas, 36 × 48 (91 × 122).

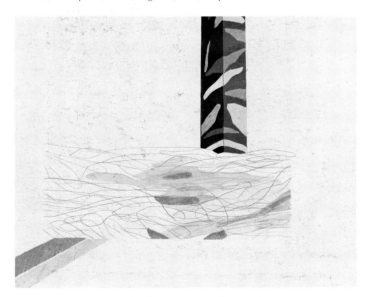

Swimming Pool, 1965. Pencil and crayon, 14 × 17 (35·5 × 43).

Hollywood Pool and Palm Tree, 1965. Crayon, 12½ × 9¾ (32 × 25).

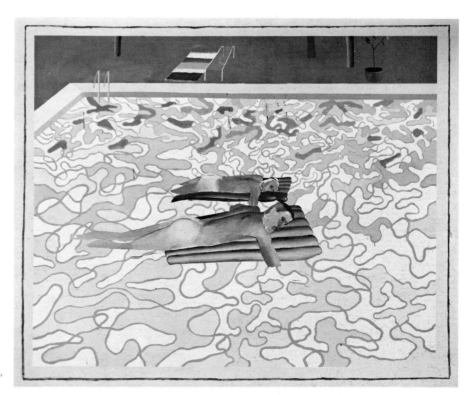

California, 1965. Acrylic on canvas,
60 × 78 (168 × 198).

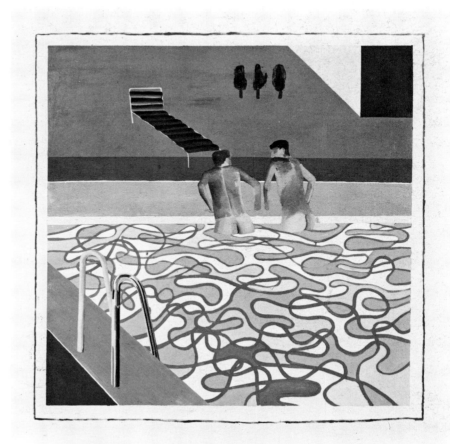

Two Boys in a Pool, Hollywood, 1965.
Acrylic on canvas, 60 × 60 (153 × 153).

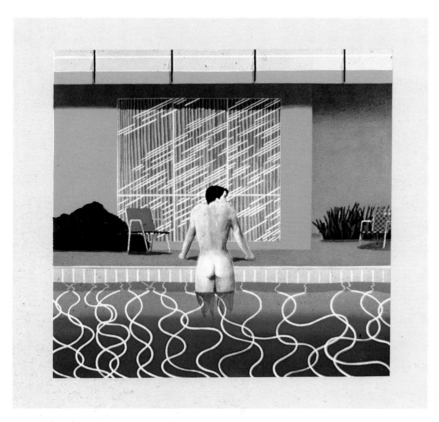

Peter Getting Out of Nick's Pool, 1966.
Acrylic on canvas, 84 × 84 (214 × 214).

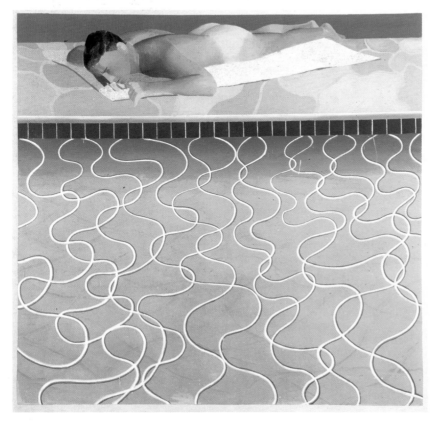

Sunbather, 1966. Acrylic on canvas,
72 × 72 (183 × 183).

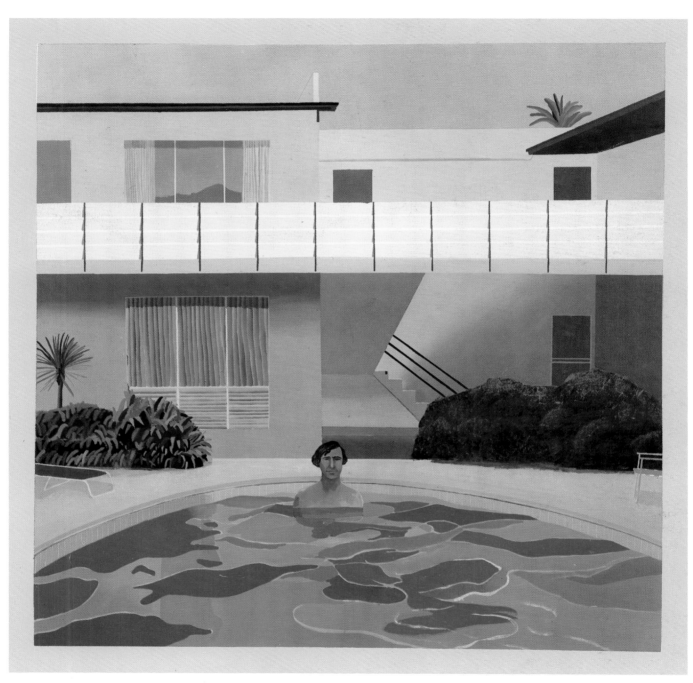

Portrait of Nick Wilder, 1966. Acrylic on canvas, 72 × 72 (183 × 183).

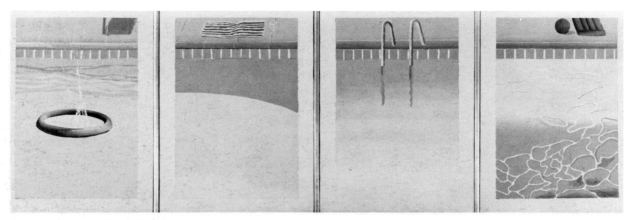

Four Different Kinds of Water, 1967.
Acrylic on canvas, 12 × 48 (31 × 122).

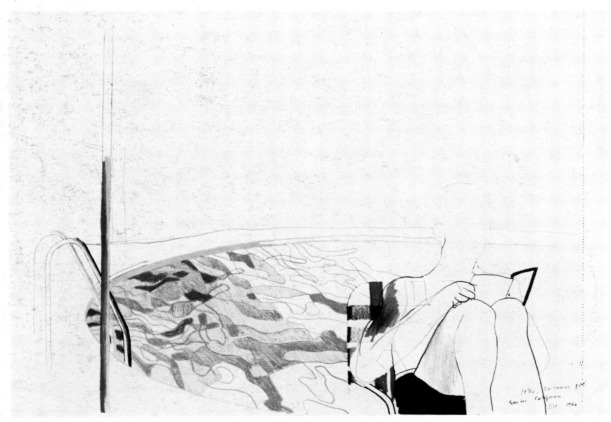

Peter, Swimming Pool, Encino, California,
1966. Crayon, 14 × 17 (35·5 × 43).

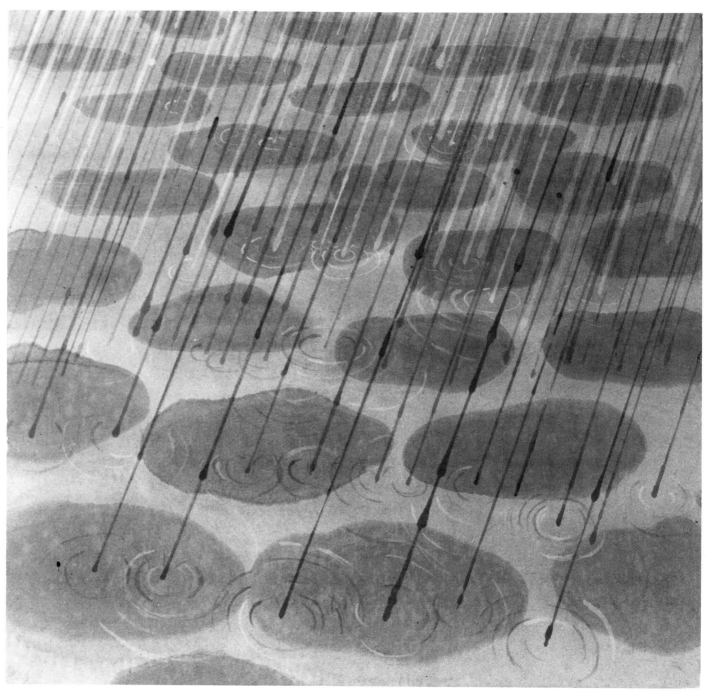

Japanese Rain on Canvas, 1972. Acrylic on canvas, 48 × 48 (122 × 122).

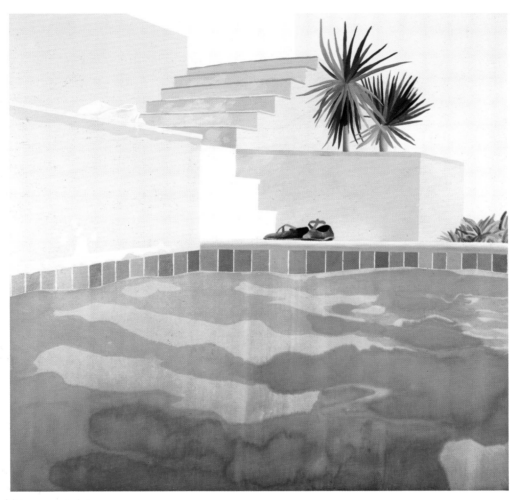

Pool and Steps, Le Nid du Duc, 1971.
Acrylic on canvas, 72 × 72 (183 × 183).

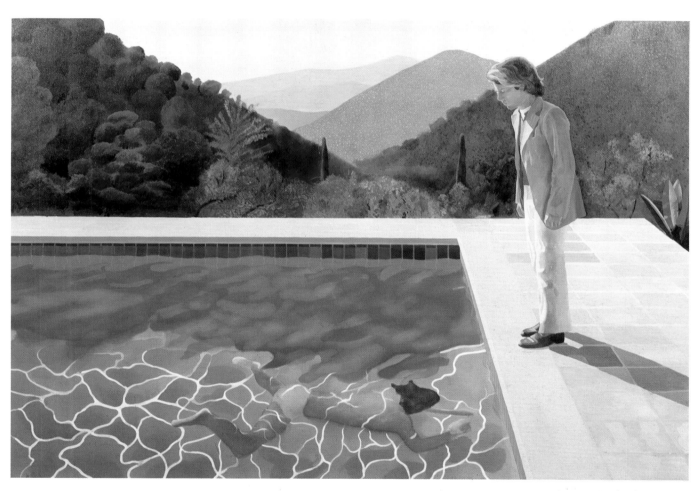

Portrait of an Artist (Pool with Two Figures), 1971. Acrylic on canvas, 84 × 120 (215 × 275).

Overleaf, *Pool drawing*, 1978. Ink, 14 × 17 (35·5 × 43).

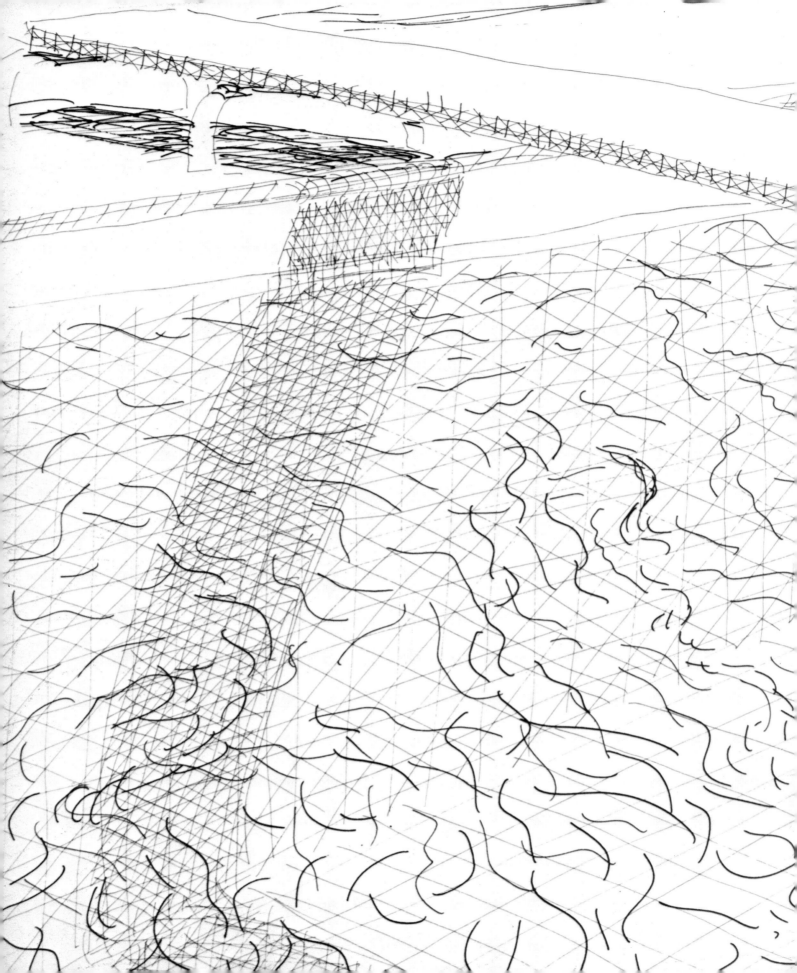

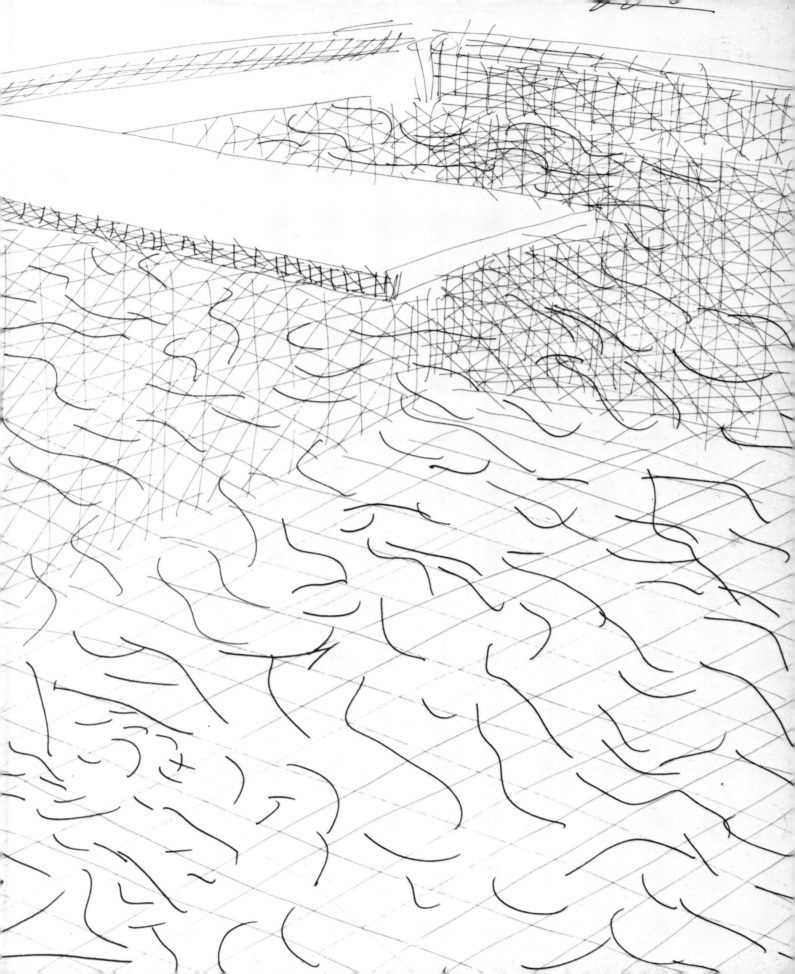

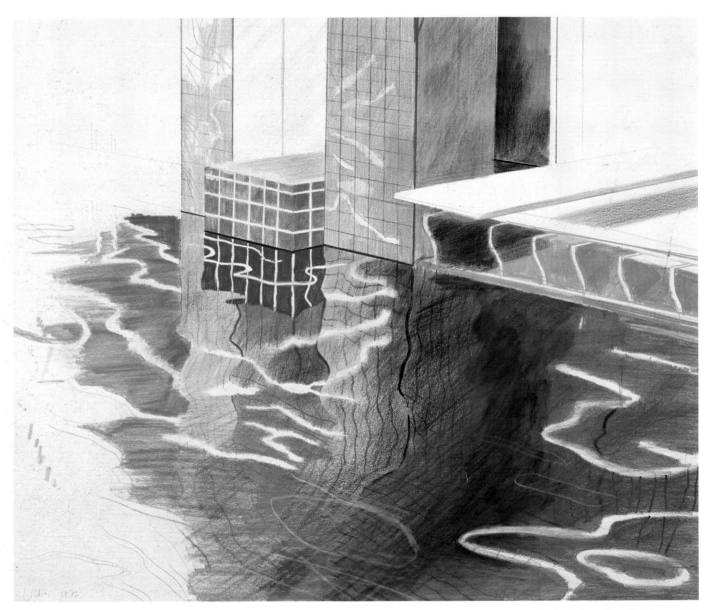

Study of Water, Phoenix, Arizona, 1976.
Crayon, 15⅞ × 19¾ (40·3 × 50).

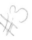

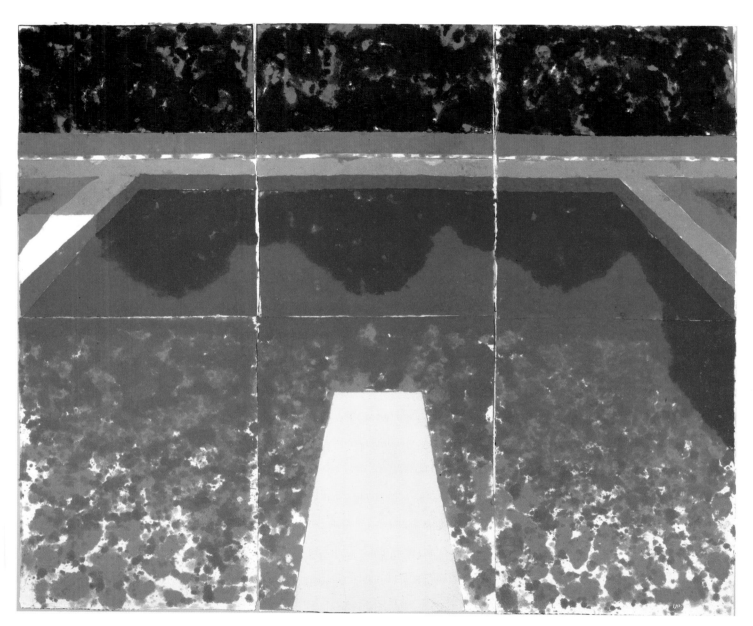

Day Pool with Three Blues, 1978. Paper Pool 7, coloured and pressed paper pulp, 71 × 85½ (183 × 218).

Portraits

I never talk when I'm drawing a person, especially if I'm making line drawings. I prefer there to be no noise at all so I can concentrate more. You can't make a line too slowly, you have to go at a certain speed; so the concentration needed is quite strong. It's very tiring as well. If you make two or three line drawings, it's very tiring in the head, because you have to do it all at one go, something you've no need to do with pencil drawing; that doesn't have to be done in one go; you can stop, you can rub out. With line drawings, you don't want to do that. You can't rub out line, mustn't do it. It's exciting doing it, and I think it's harder than anything else; so when they succeed, they're much better drawings, often. The failure rate amongst my line drawings is still high; I'm always tearing them up and putting crosses through them, because you can't touch them up. If you draw the leg all wrong, you just have to throw it away. That's not the case with drawing on a canvas because you can alter it, move it about, draw with pencil, rub it out. And usually I'm drawing on the canvas from another drawing, so the decisions are made.

Mother (wearing black dress with white spots), 1972. Crayon, 17 × 14 (43 × 35·5).

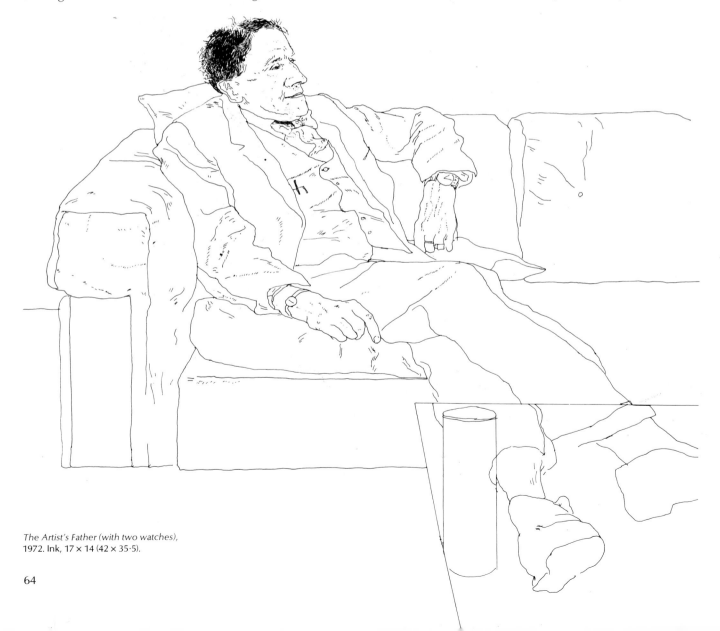

The Artist's Father (with two watches),
1972. Ink, 17 × 14 (42 × 35·5).

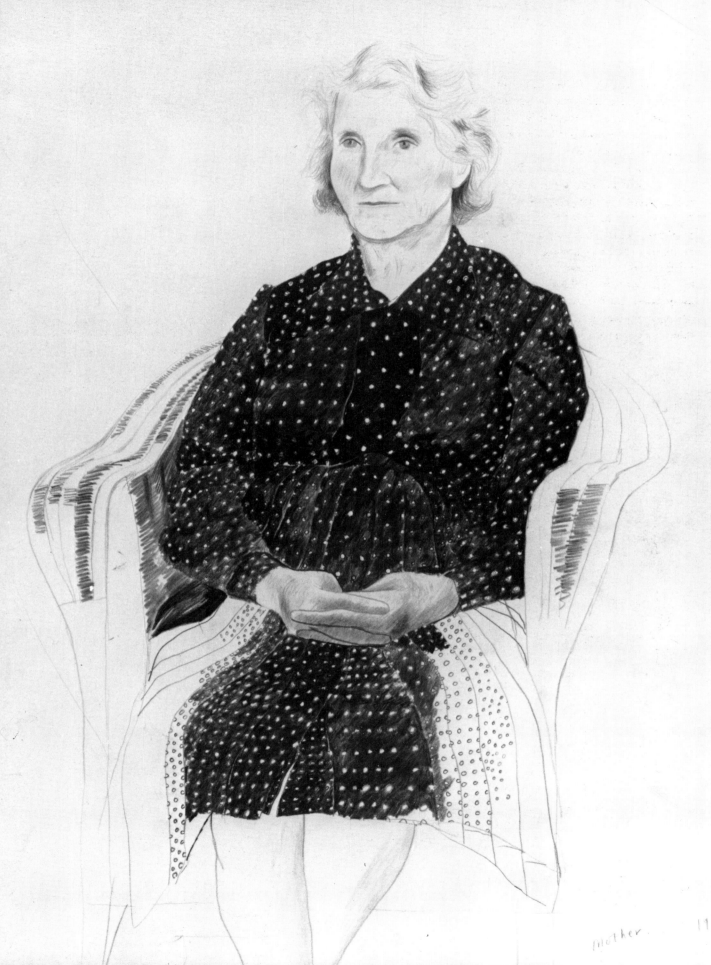

Mother. 1972

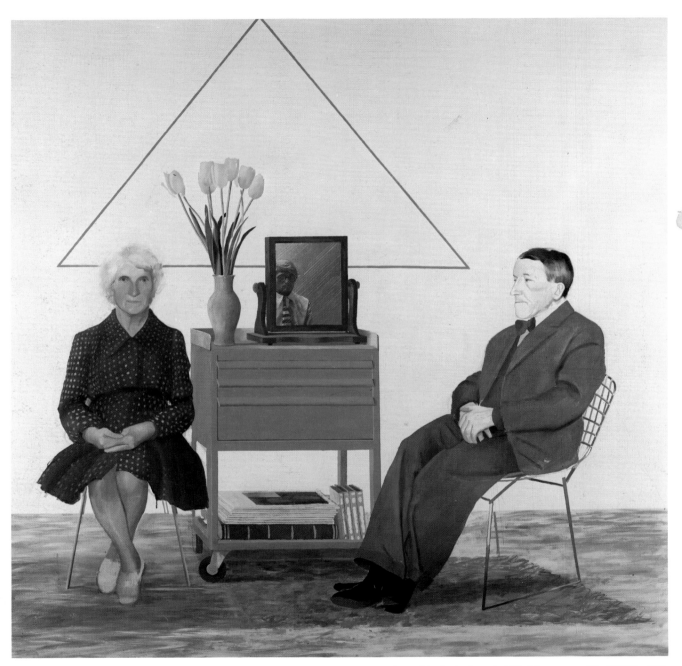

My Parents and Myself (unfinished state), 1975. Oil on canvas, 72 × 72 (183 × 183).

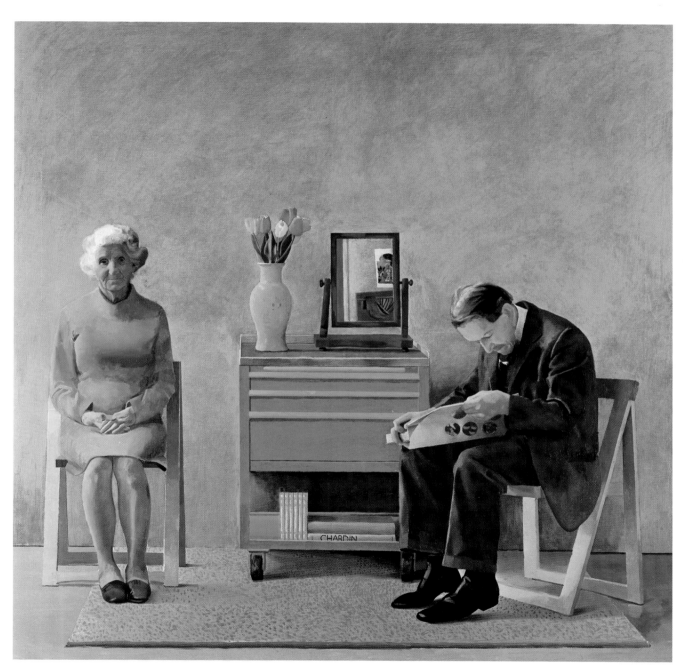

My Parents, 1977. Oil on canvas, 72 × 72 (183 × 183).

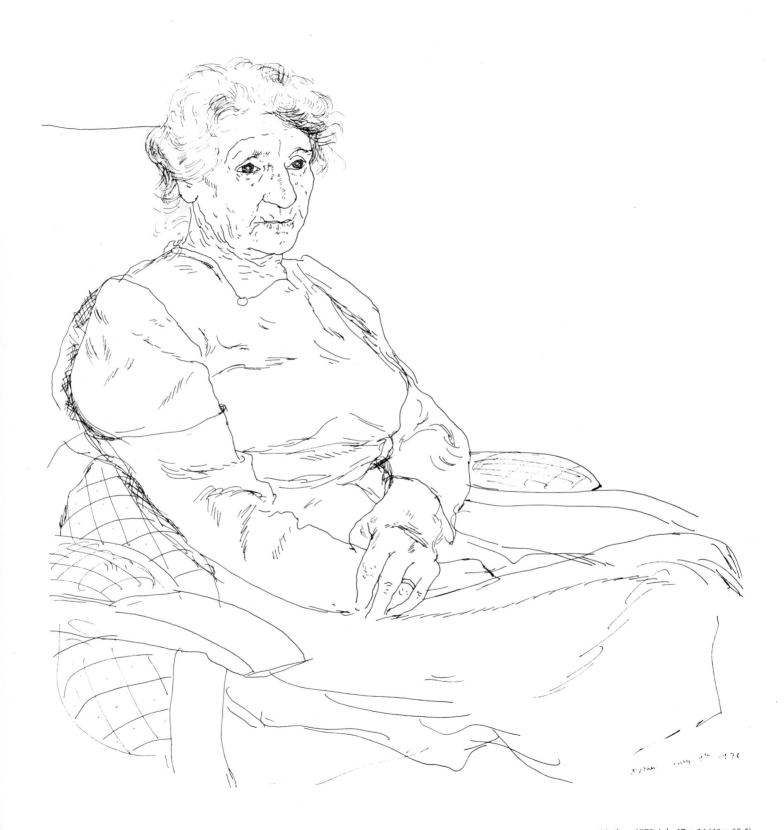

Mother, 1978. Ink, 17 × 14 (43 × 35·5).

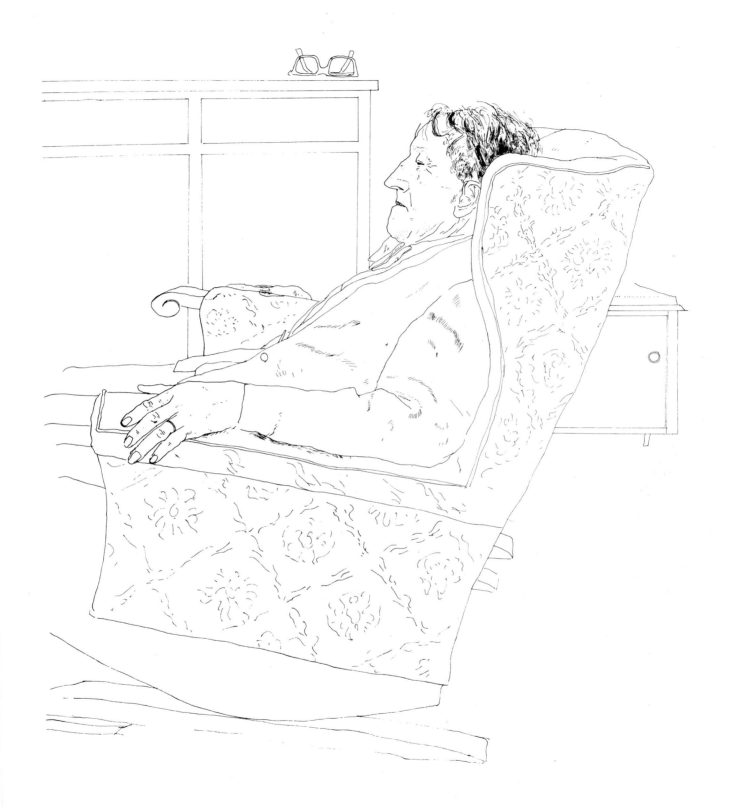

Artist's Father, 1975. Ink, 17 × 14 (43 × 35·5).

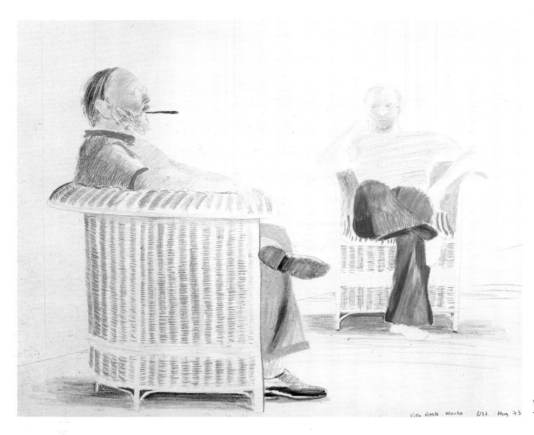

Villa Reale, Marlia, 1973. Crayon, 14 × 17 (35·5 × 43).

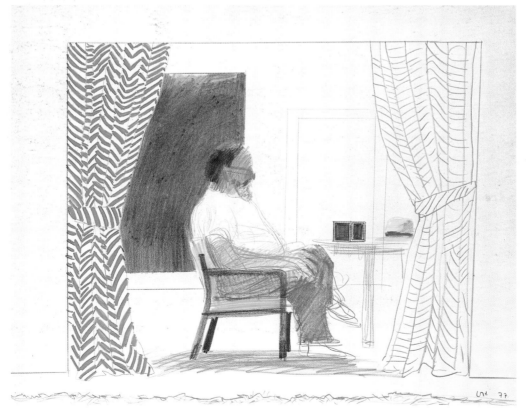

Henry Geldzahler Seated, 1977. Crayon, 14 × 17 (35·5 × 43).

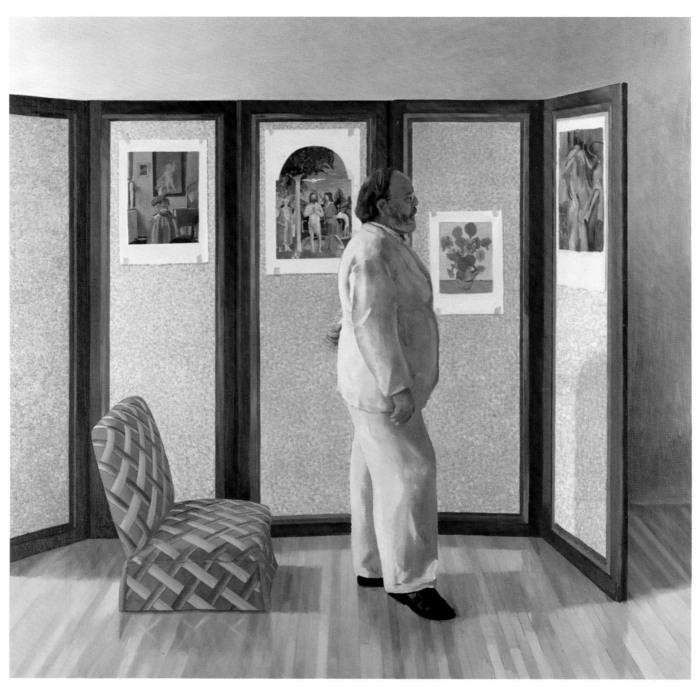

Looking at Pictures on a Screen, 1977. Oil on canvas, 72 × 72 (183 × 183).

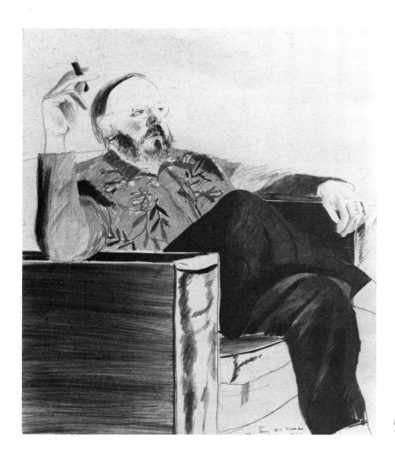

Henry, Seventh Avenue, 1972. Crayon, 17 × 14 (43 × 35·5).

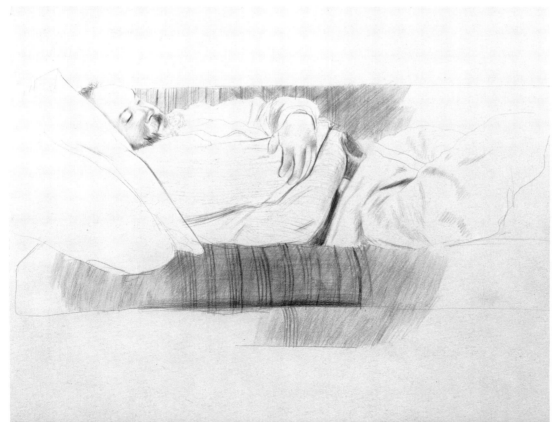

Henry Sleeping, Hollywood, 1976. Crayon, 14 × 17 (35·5 × 43).

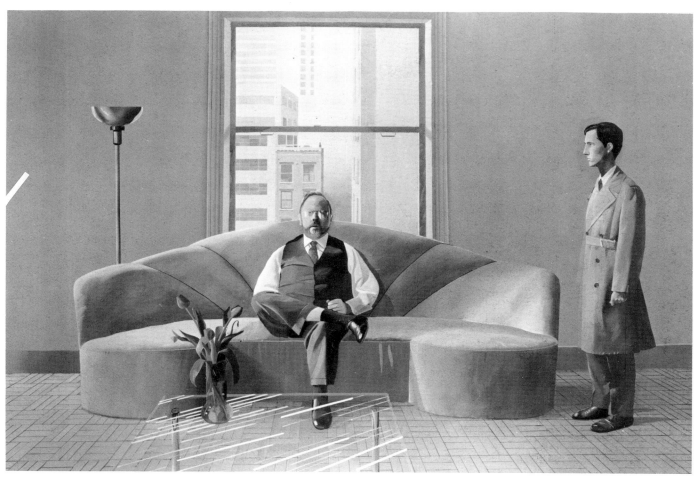

Henry Geldzahler and Christopher Scott,
1969. Acrylic on canvas, 84 × 120
(214 × 305).

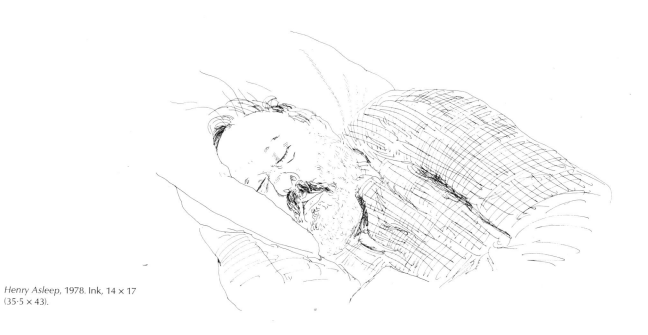

Henry Asleep, 1978. Ink, 14 × 17
(35·5 × 43).

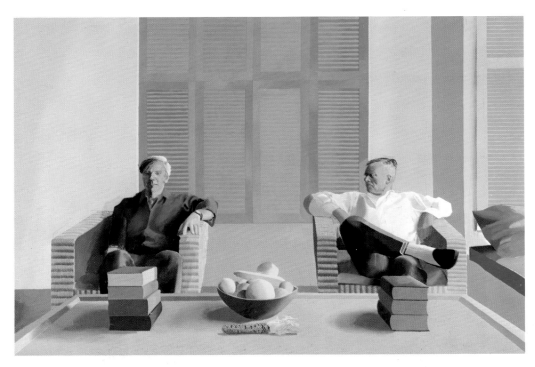

Christopher Isherwood and Don Bachardy, 1968. Acrylic on canvas, 83½ × 119½ (212 × 304).

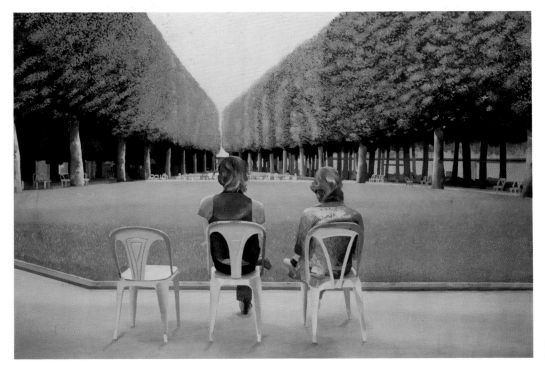

Le parc des sources, Vichy, 1970. Acrylic on canvas, 84 × 120 (214 × 305).

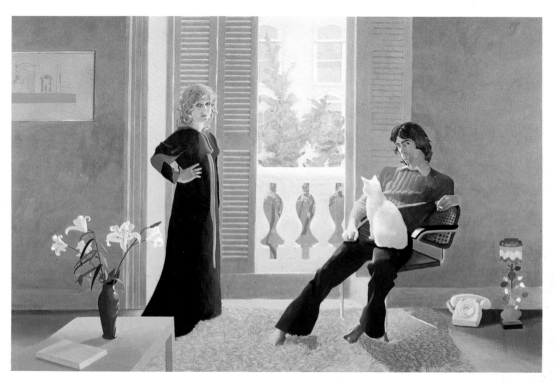

Mr and Mrs Clark and Percy, 1970–71.
Acrylic on canvas, 84 × 120 (214 × 305).

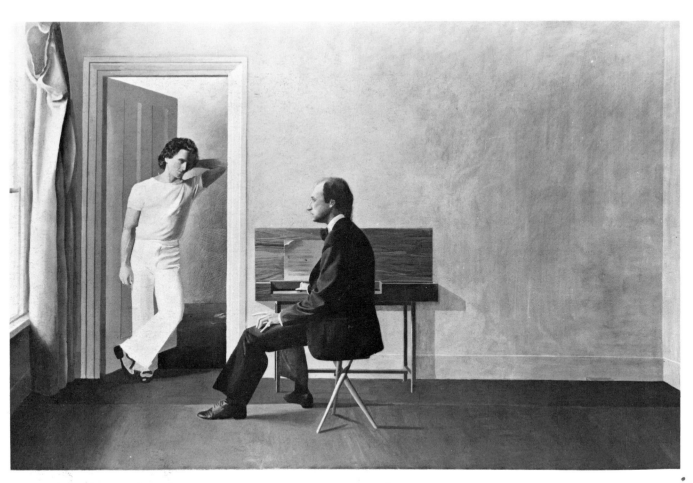

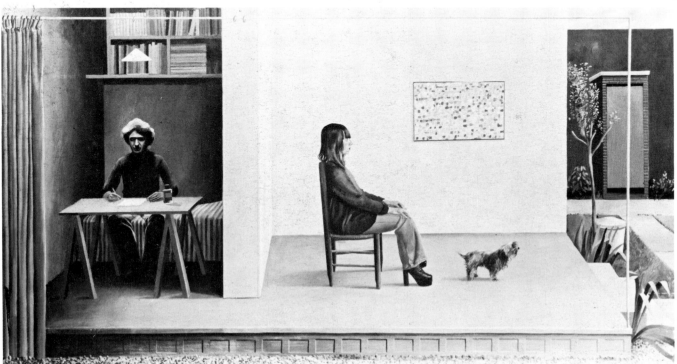

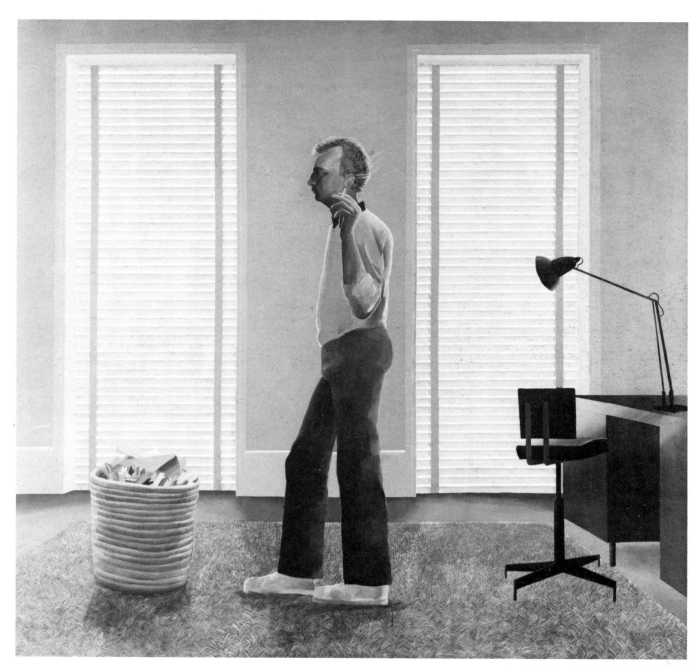

The Room, Manchester Street, 1967.
Acrylic on canvas, 96 × 96 (244 × 244).

George Lawson and Wayne Sleep
(unfinished), 1975. Acrylic on canvas,
120 × 84 (304·8 × 213·4).

Gregory Masurovsky and Shirley Goldfarb,
1974. Oil on canvas, 48 × 84 (122 × 213·4).

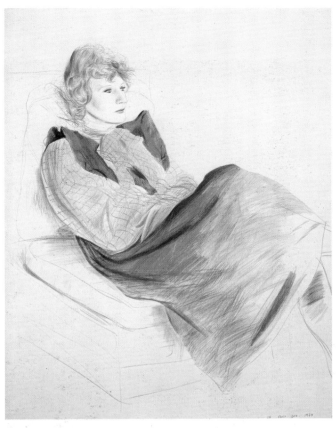

Celia Wearing Checked Sleeves, 1973.
Crayon, 25½ × 19¾ (65 × 50).

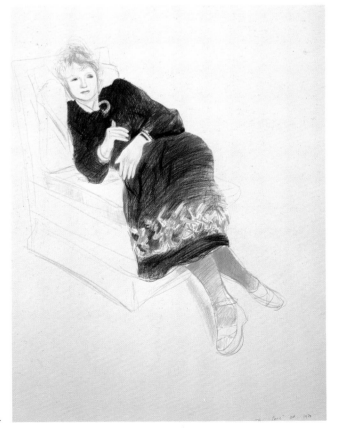

Celia in a Black Dress with Coloured Border, 1973. Crayon, 25½ × 19¾ (65 × 50).

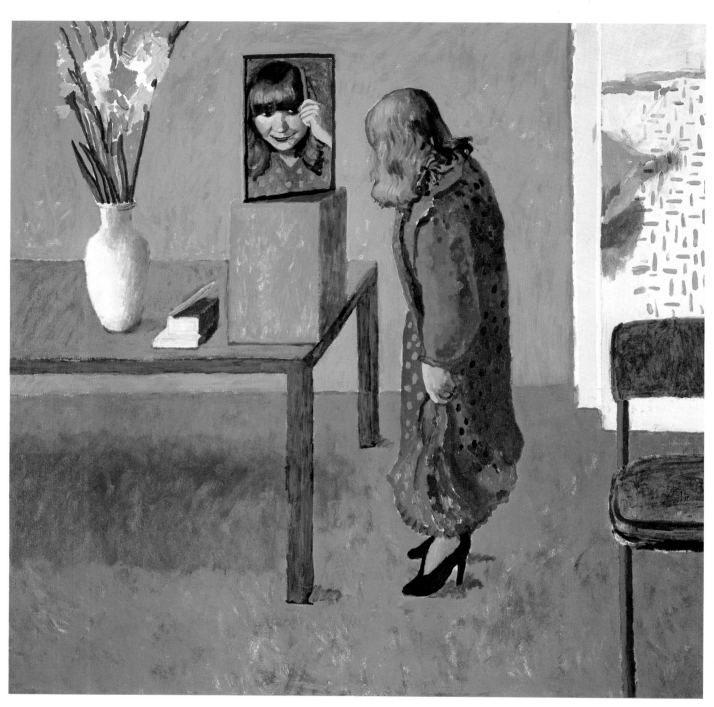

Ann Upton Combing her Hair, 1979.
Acrylic on canvas, 60 × 60 (153 × 153).

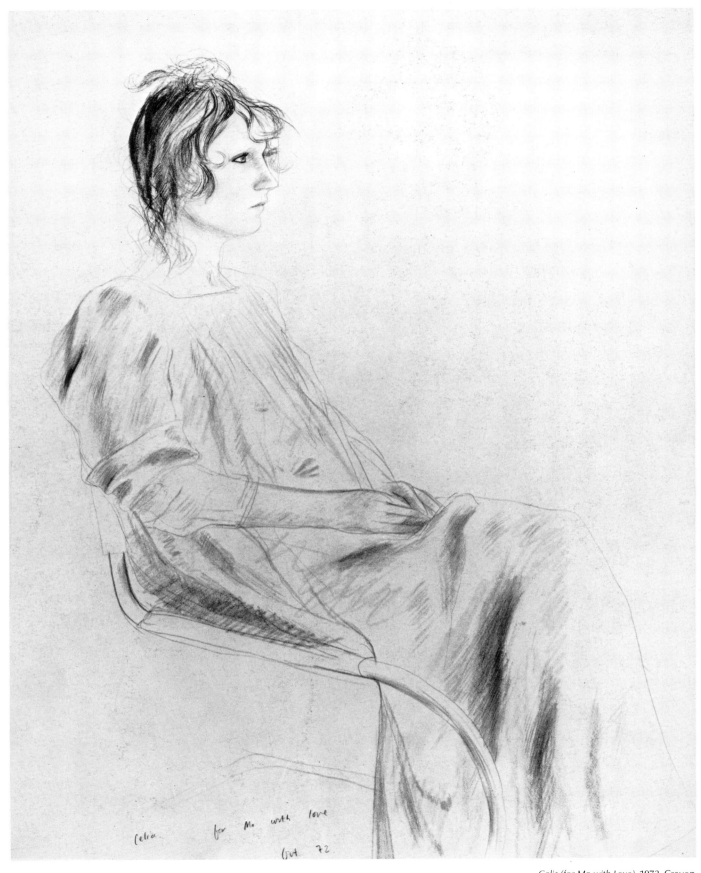

Celia (for Mo with Love), 1972. Crayon,
17 × 14 (43 × 35·5).

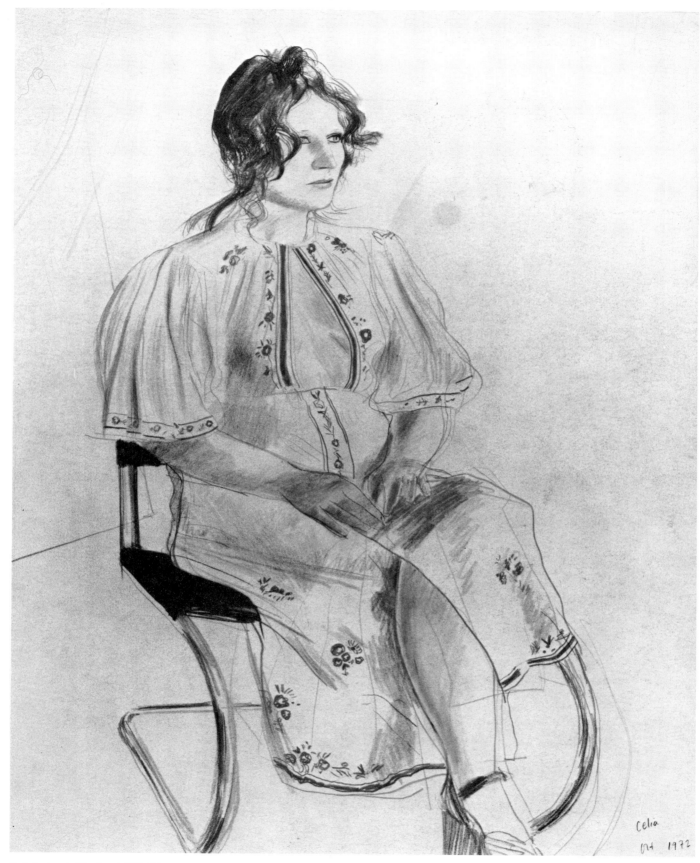

Celia (red and white dress), 1972. Crayon,
17 × 14 (43 × 35·5).

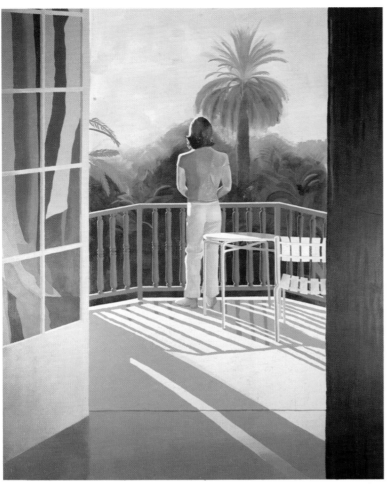

Sur la terrasse, 1971. Acrylic on canvas,
180 × 84 (457 × 214).

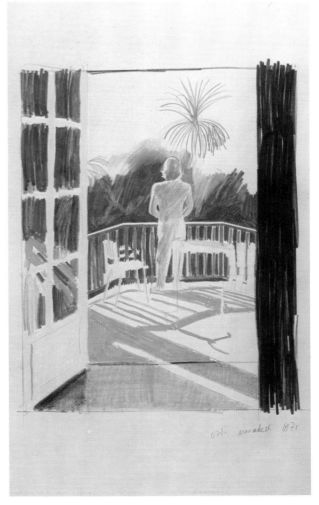

Peter on Balcony, 1971. Crayon, 13¾ × 10½
(35 × 27).

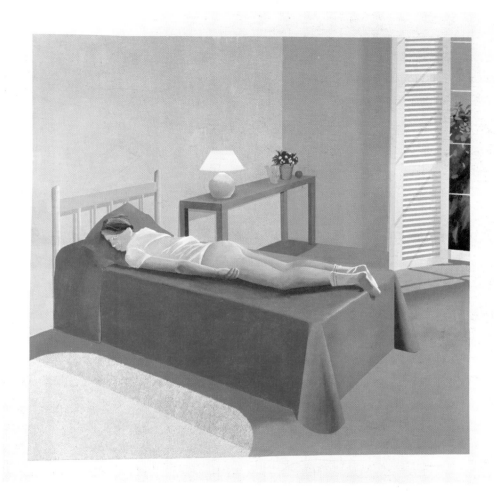

The Room, Tarzana, 1967. Acrylic on canvas, 96 × 96 (244 × 244).

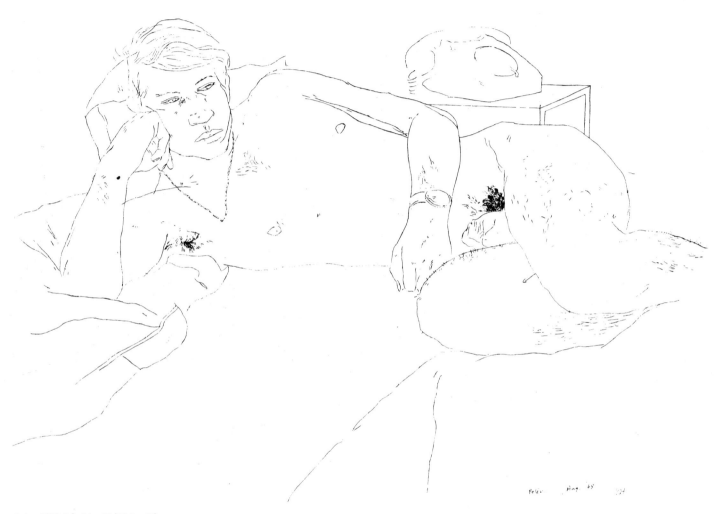

Peter, 1968. Ink, 14 × 17 (35·5 × 43).

Peter, 1972. Ink, 17 × 14 (43 × 35·5).

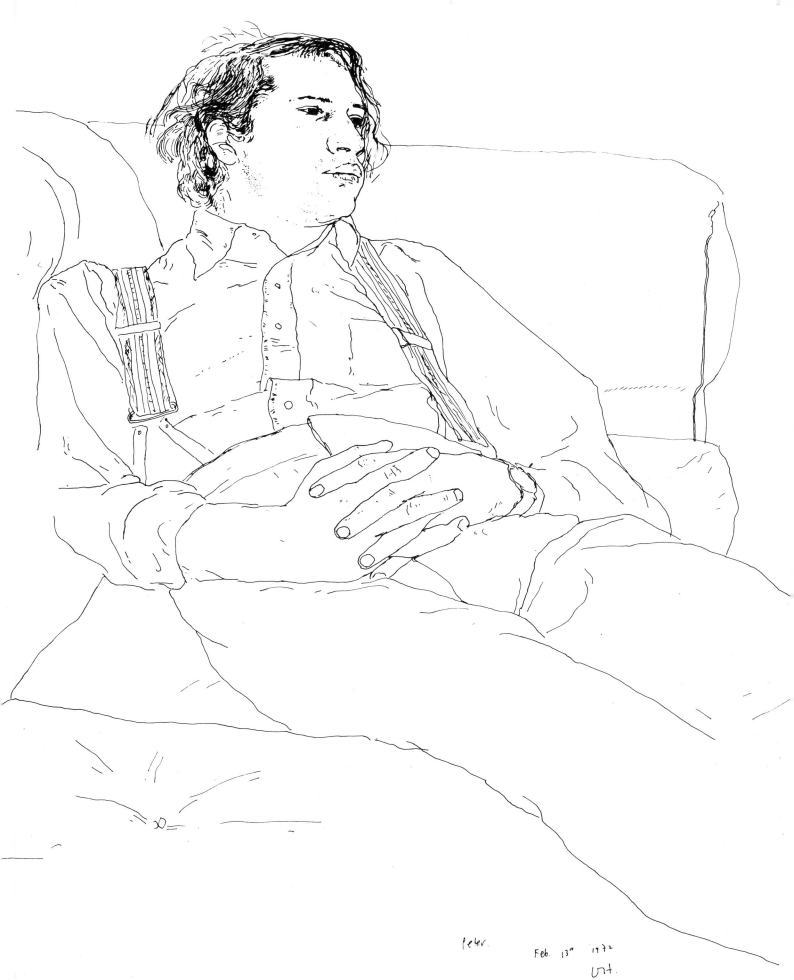

Peter. Feb. 13th 1972

DH.

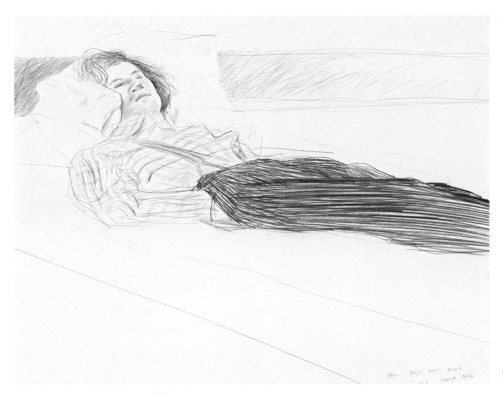

Peter, Platzel Hotel, Munich, 1972. Crayon,
17 × 14 (43 × 35·5).

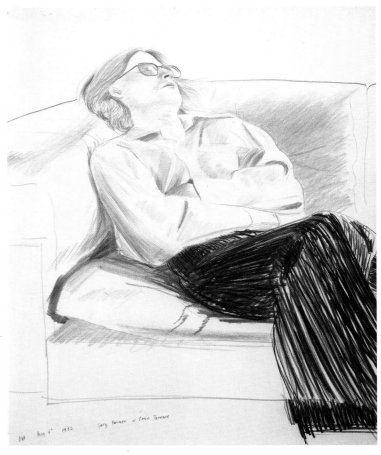

Gary Farmer at Powis Terrace, 1972.
Crayon, 17 × 14 (43 × 35·5).

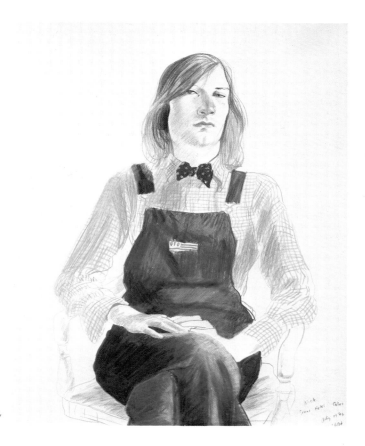

Nick, Grand Hotel, Calvi, 1972. Crayon,
17 × 14 (43 × 35·5).

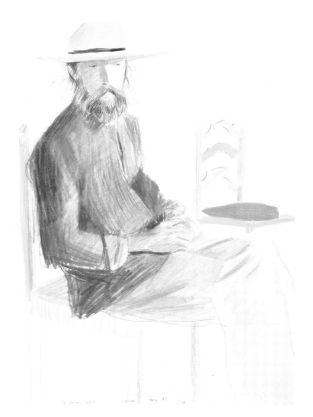

Dr Eugen Lamb, Lucca, 1973. Crayon,
23 × 20 (60 × 51).

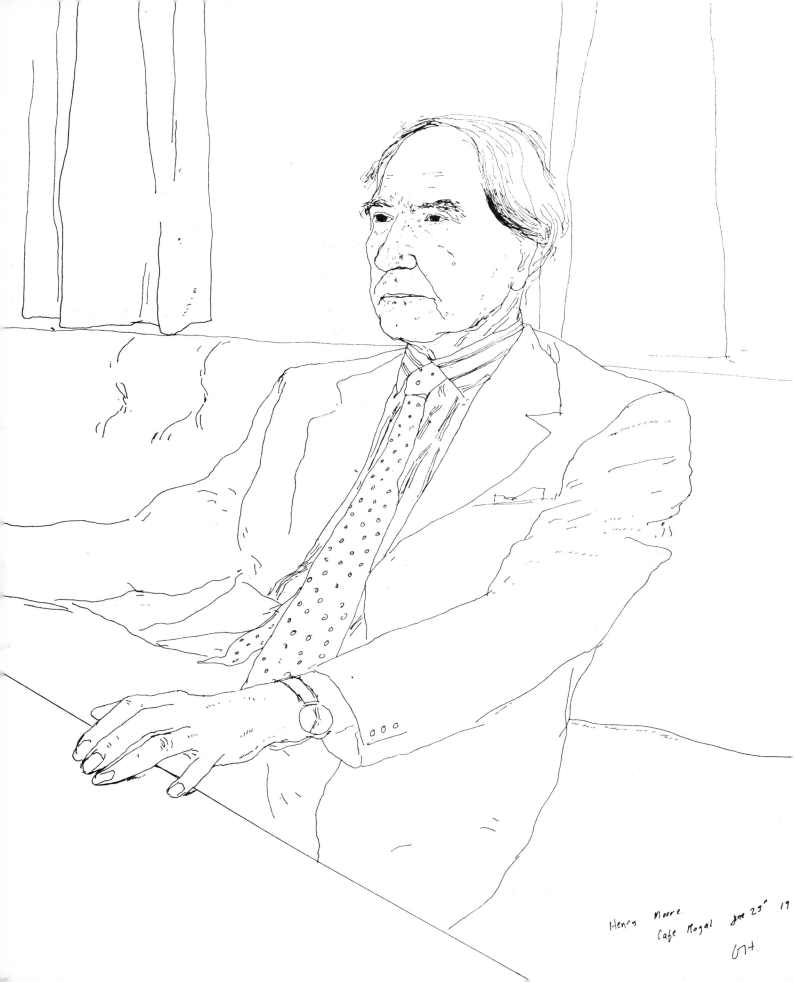

Henry Moore
Cafe Royal June 25" 19

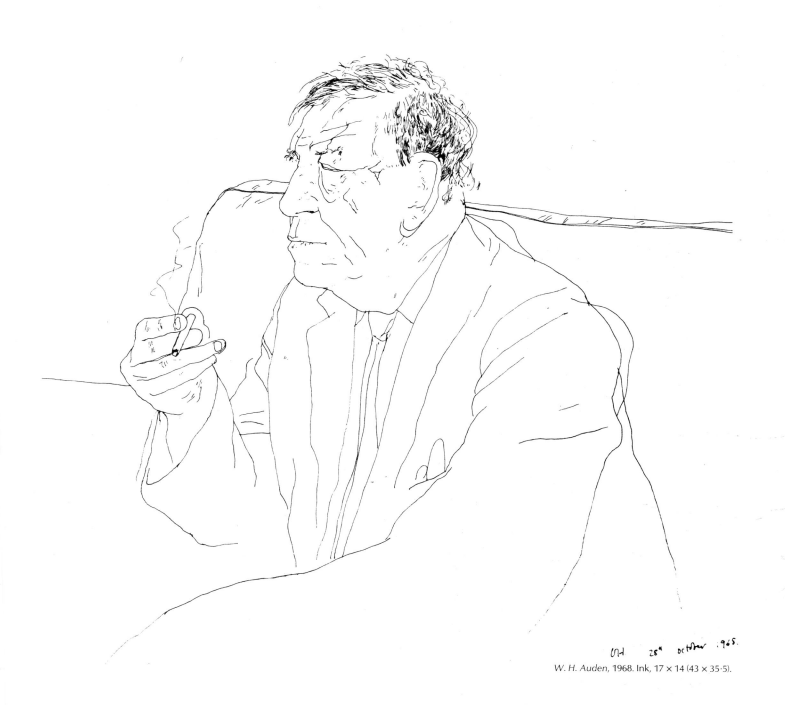

W. H. Auden, 1968. Ink, 17 × 14 (43 × 35·5).

Henry Moore at the Café Royal, 1972. Ink, 17 × 14 (43 × 35·5).

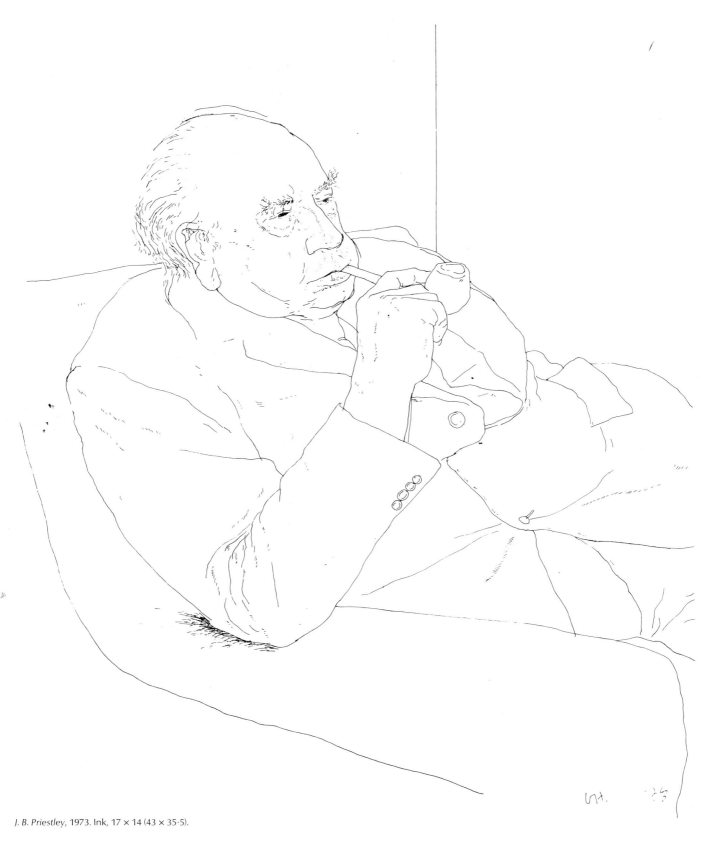

J. B. Priestley, 1973. Ink, 17 × 14 (43 × 35·5).

Ron Kitaj outside Akademie der Künste, Vienna, 1975. Ink, 14 × 17 (35·5 × 43).

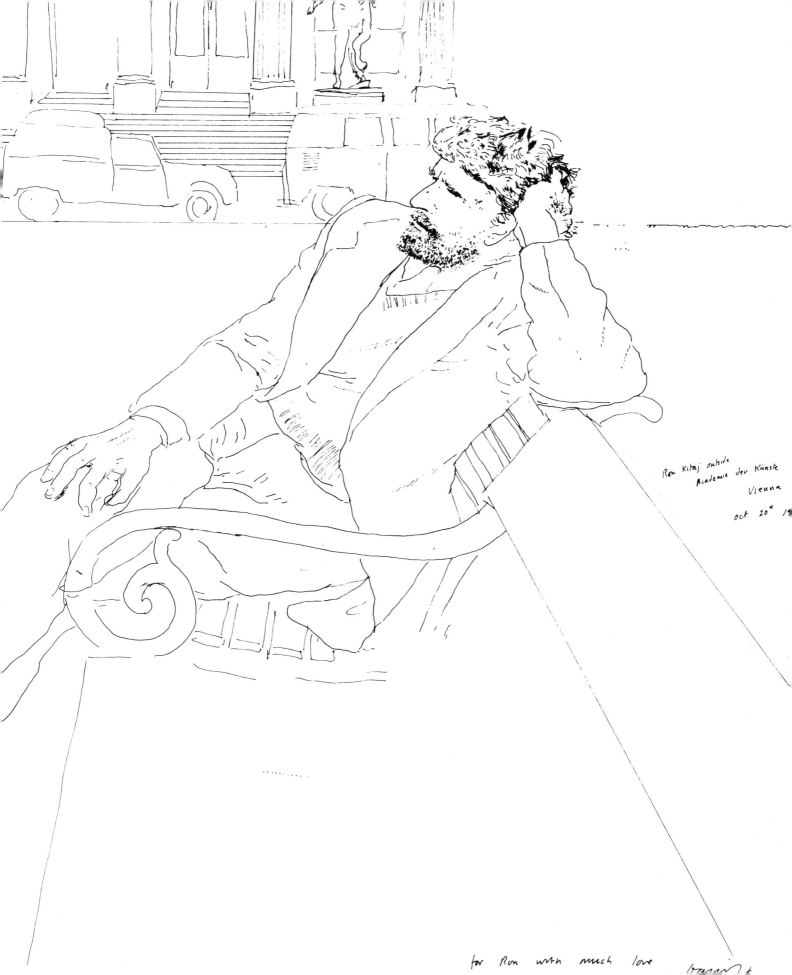

Ron Kitaj outside
Academie der Künste
Vienna
Oct 20th 19

for Ron with much love

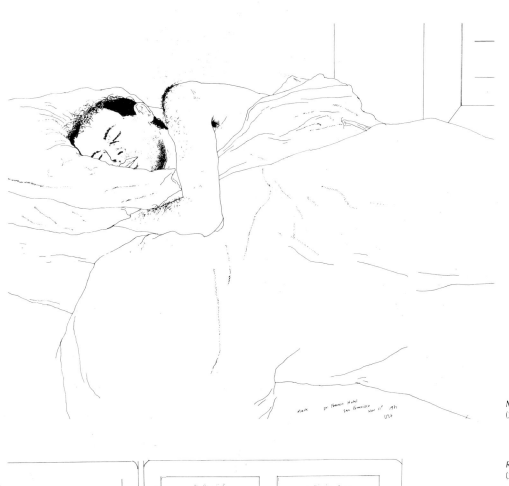

Mark, St Francis Hotel, 1971. Ink, 14 × 17
(35·5 × 43).

Randy Sleeping, 1976. Ink, 14 × 17
(35·5 × 43).

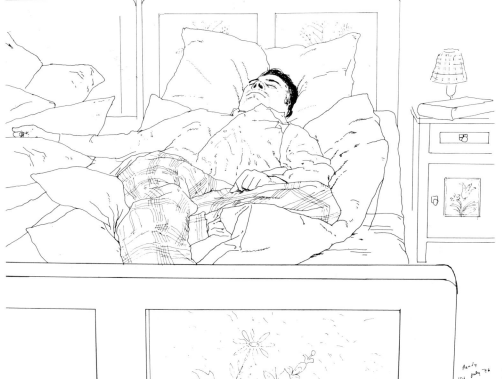

Mark, Mandarin Hotel, 1971. Ink, 17 × 14
(43 × 35·5).

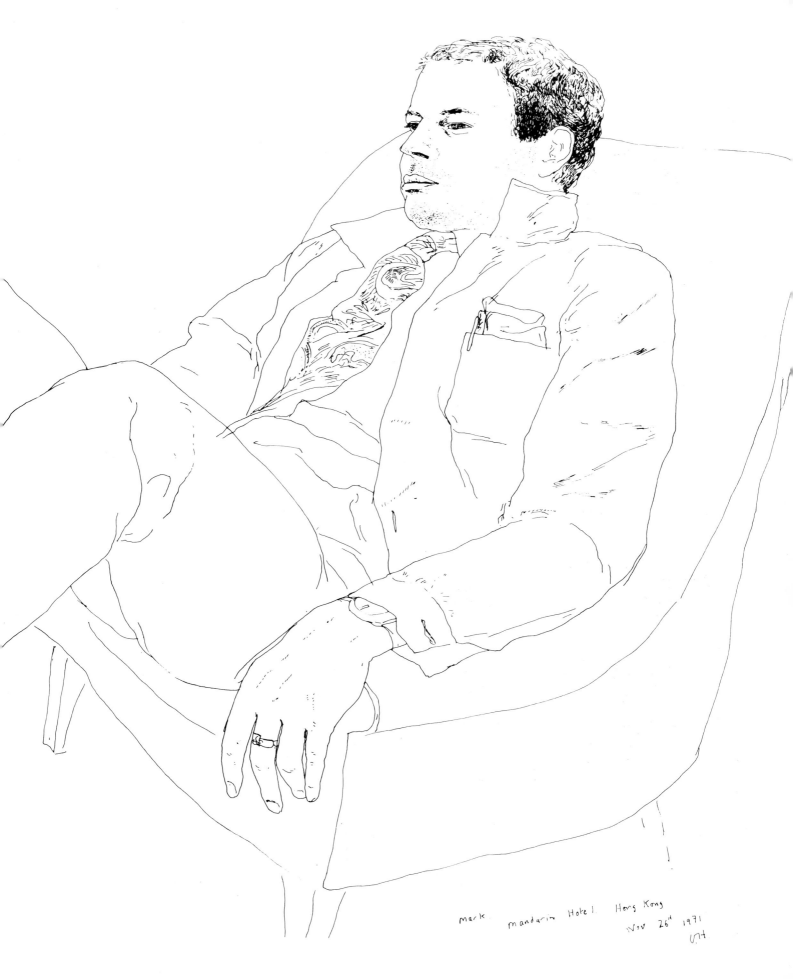

Mark Mandarin Hotel Hong Kong
 Nov 26th 1971
 DH

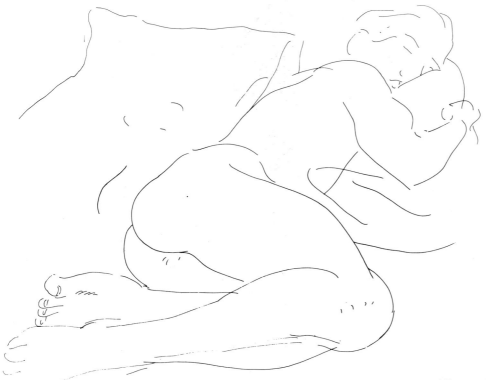

Nude Boy, 1978. Ink, 14 × 17 (35·5 × 43).

Kasmin Reading the Udaipur Guide, April 1977. Ink, 14 × 17 (35·5 × 43).

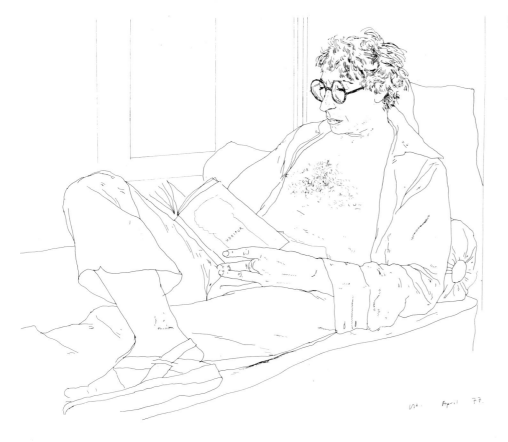

Maurice, 1977. Ink, 17 × 14 (43 × 35·5).

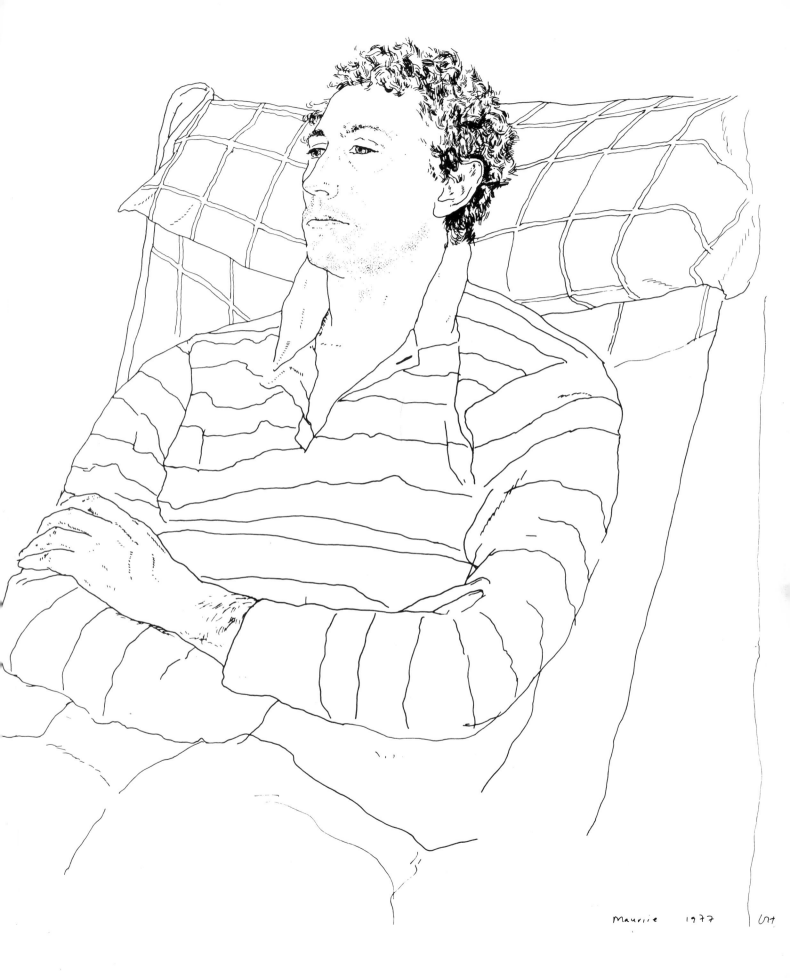

Maurice 1977

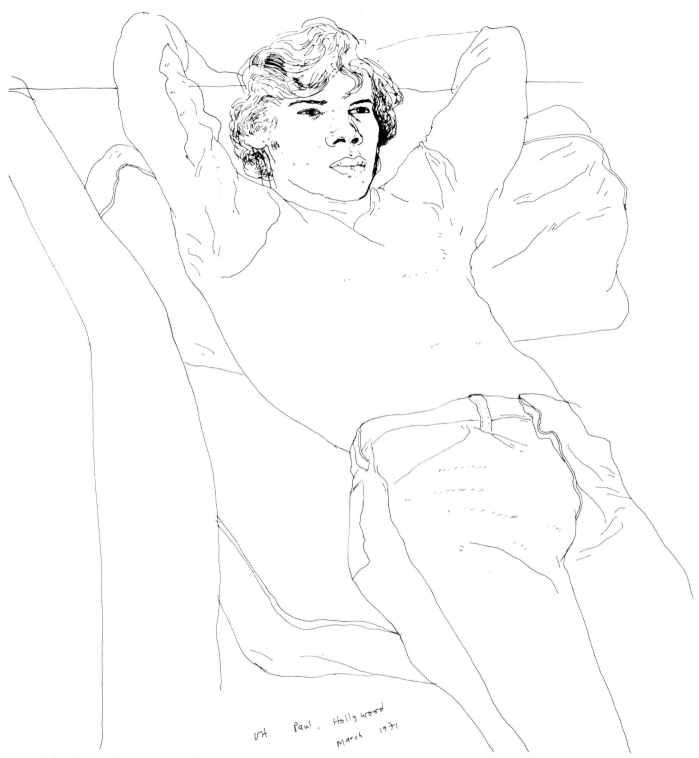

Paul, Hollywood, 1971. Ink, 17 × 14 (43 × 35·5).

Gregory Thinking in the Palatine Ruins, 1974. Ink, 25½ × 19¾ (65 × 50).

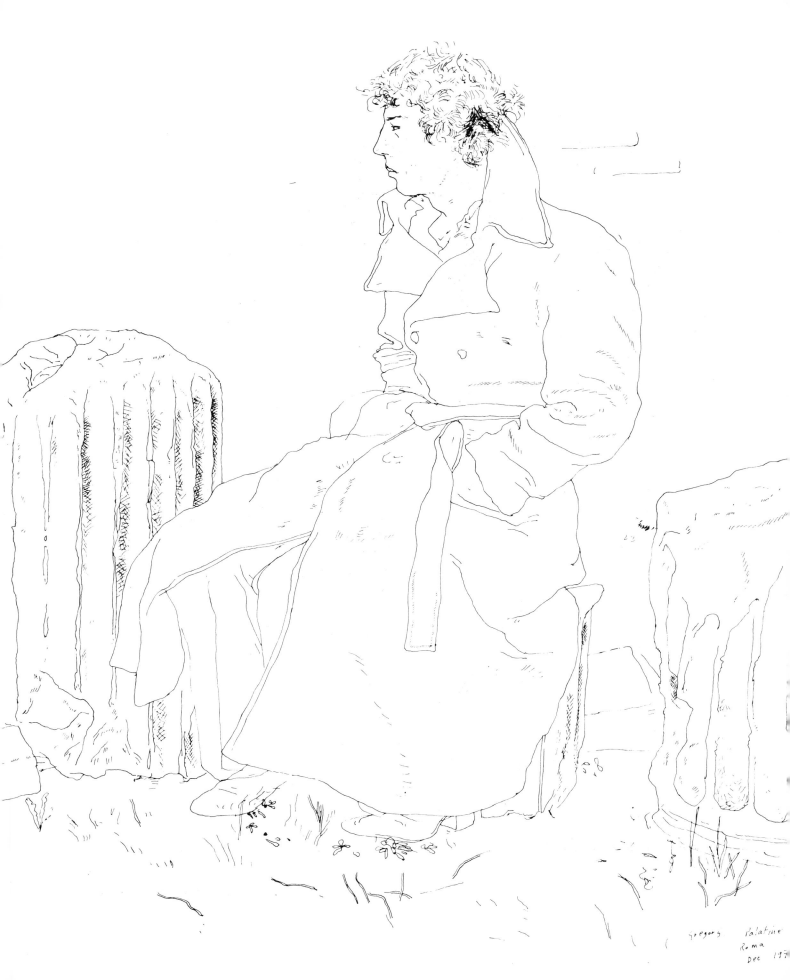

Gregory Palatine
Roma
Dec 197

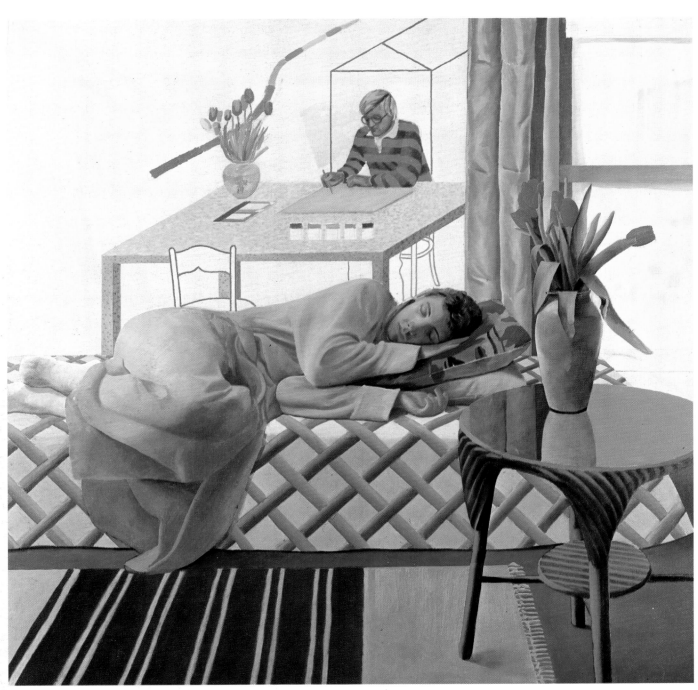

Model with Unfinished Self Portrait, 1977. Oil on canvas, 60 × 60 (152·4 × 152·4).

Detail from *Model with Unfinished Self Portrait*.

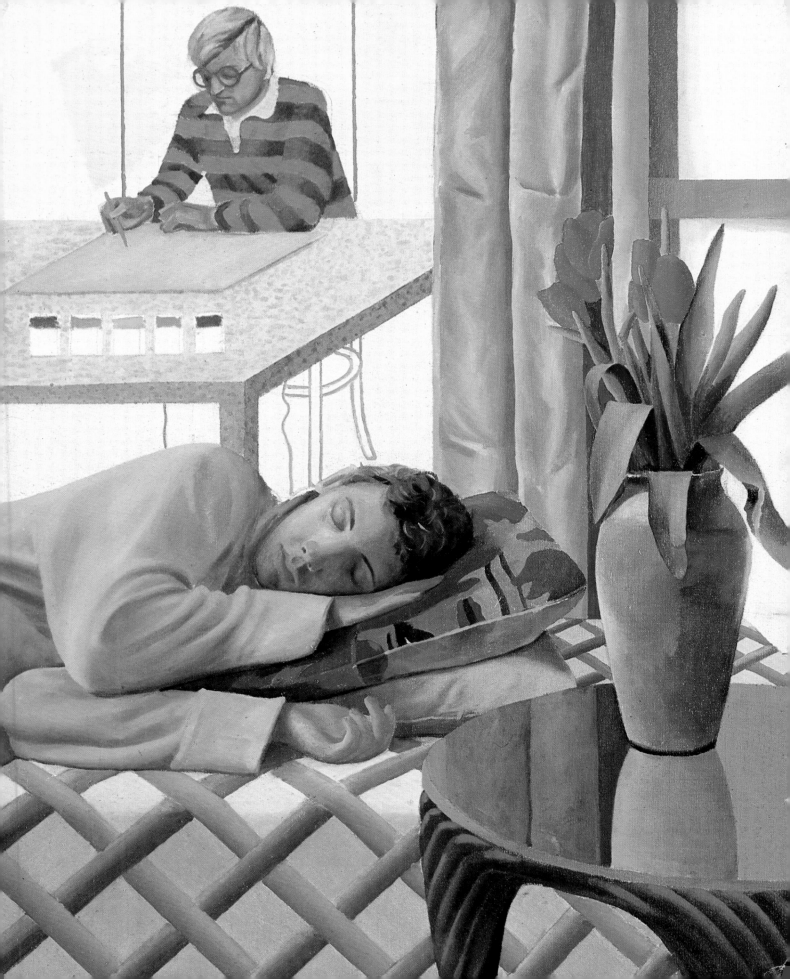

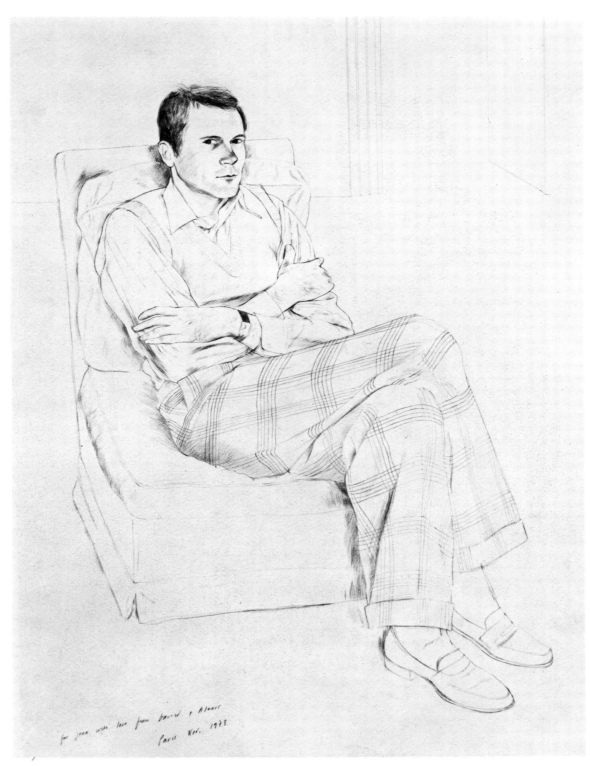

Portrait of Jean Léger, 1973. Pencil, 25½ × 19¾ (65 × 50).

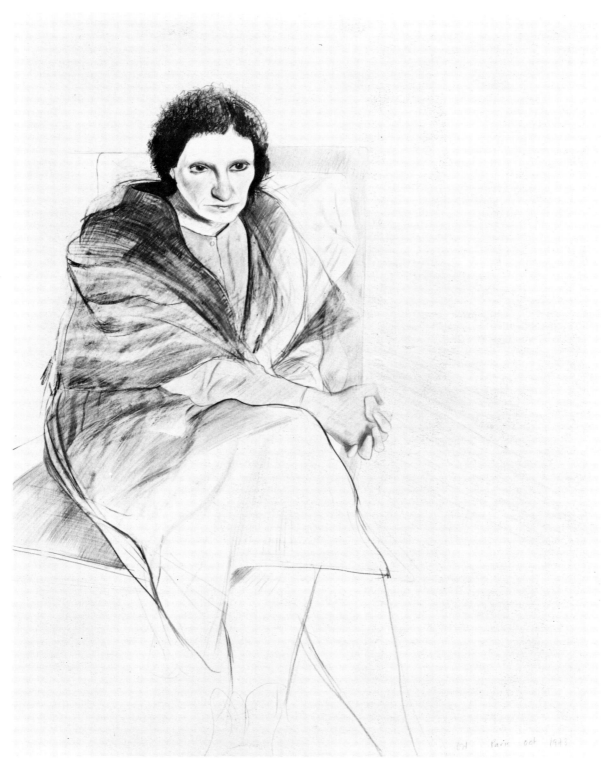

Lila di Nobilis, Paris, 1973. Crayon, 25½ × 19¾ (65 × 50).

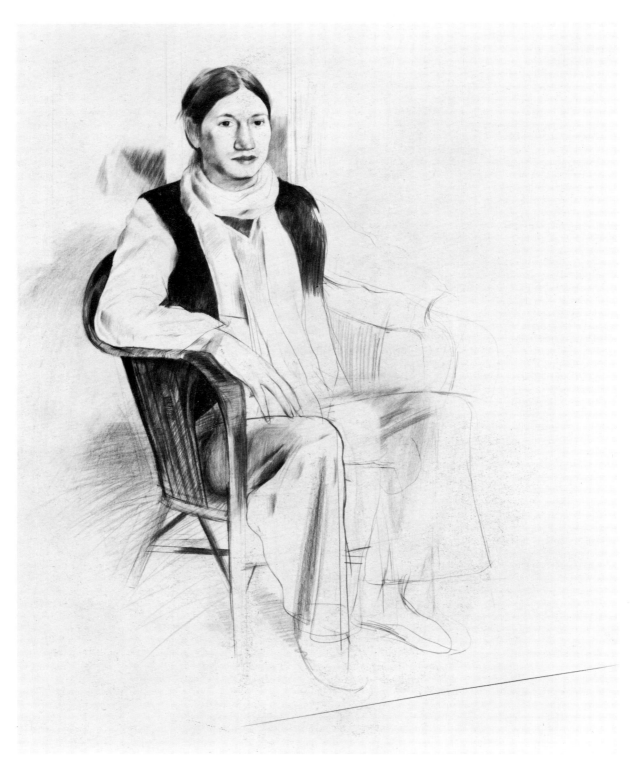

Carlos, 1975. Crayon, 25½ × 19¾ (65 × 50).

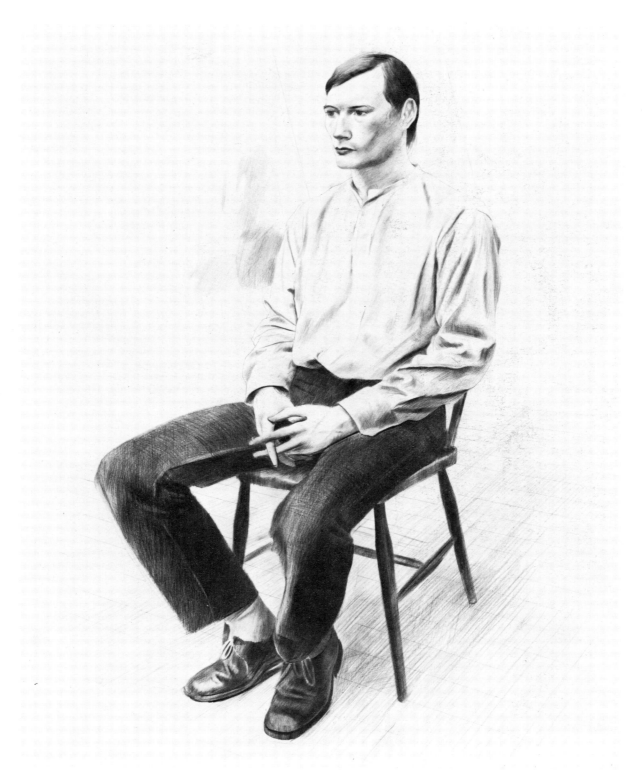

Nicky Rae, 1975. Crayon, 25½ × 19¾ (65 × 50).

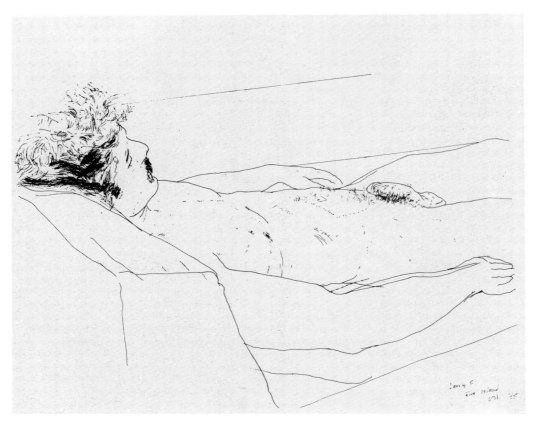

Larry S., Fire Island, 1975. Ink, 14 × 17
(35·5 × 43).

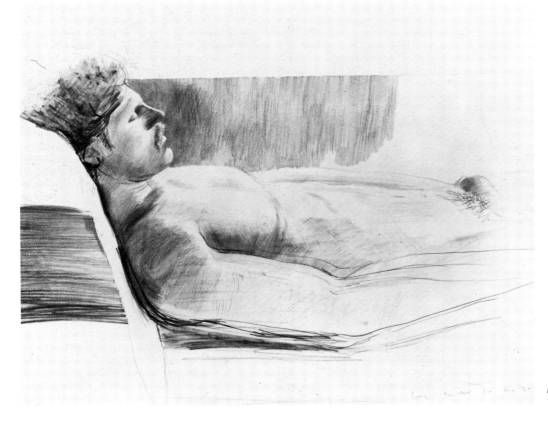

Larry, Fire Island, 1975. Crayon
14 × 17 (35·5 × 43).

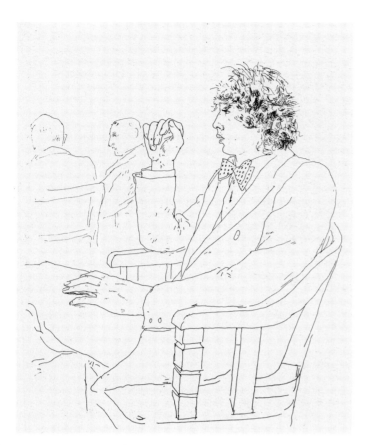

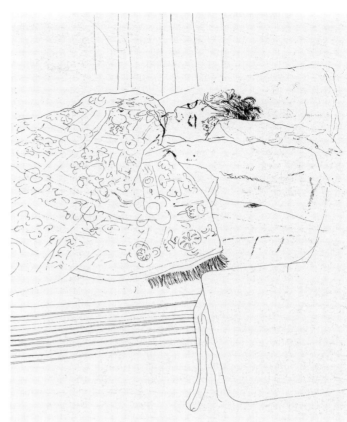

Gregory, Arizona Biltmore, 1976.
Ink, 17 × 14 (43 × 35·5).

Gregory in bed, Hollywood, 1976.
Ink, 17 × 14 (43 × 33·5).

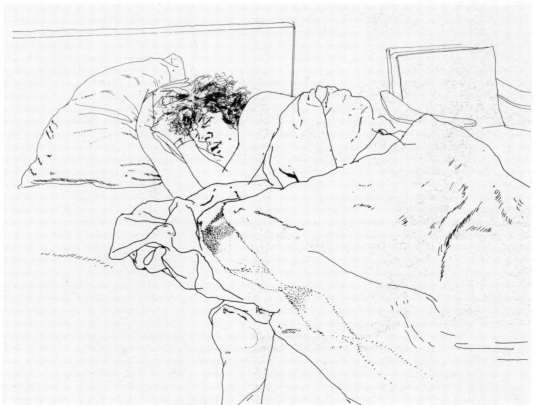

*Gregory Asleep, Sunday Inn,
Houston*, 1976. Ink, 14 × 17
(35·5 × 43).

Travels

I met some English kids at a bar in Los Angeles and they said to me, Why don't you live here anymore (in 1973)? And I said, I'm living in Paris. But California is the place I always run to. Coming back to Europe you realize it's more interesting to drive around than America. America's wonderful as landscape, but every time you pull into a restaurant you know what the menu's going to be.

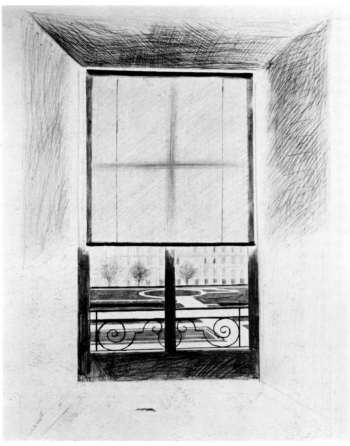

Study for Louvre Window, No.2, 1974.
Crayon, 41½ × 29½ (105·4 × 74·9).

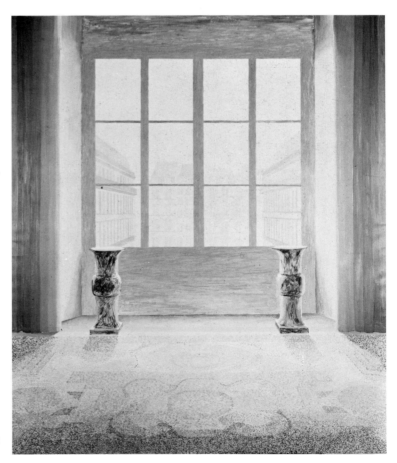

Two Vases in the Louvre, 1974. Oil on canvas, 72 × 60 (184 × 152·5).

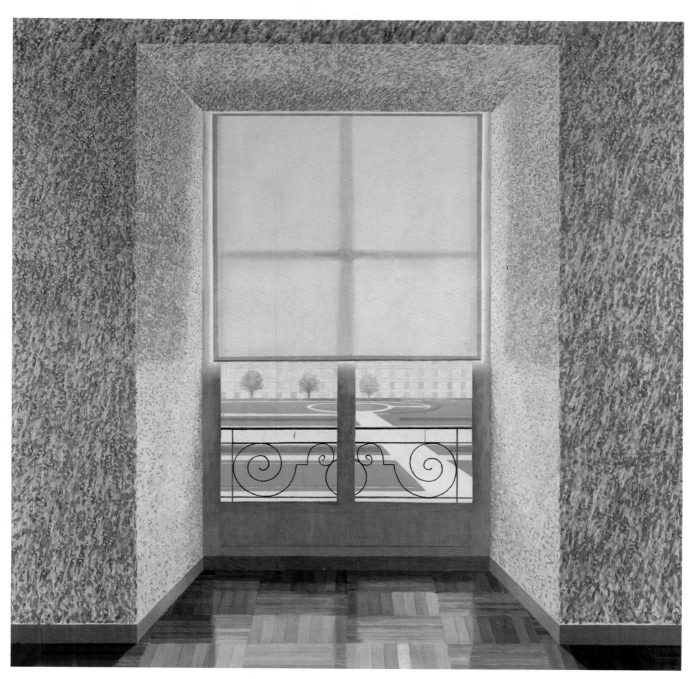

Contre-jour in the French Style — Against the Day dans le style français, 1974. Oil on canvas, 72 × 72 (183 × 183).

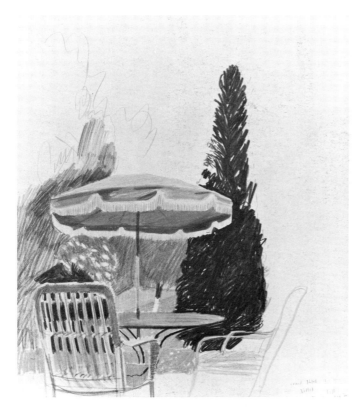

Grand Hotel Terrace, Vittel, 1970. Crayon,
17 × 14 (43 × 35·5).

Chairs, Mamounia Hotel, Marrakesh, 1971.
Crayon, 14 × 17 (35·5 × 43).

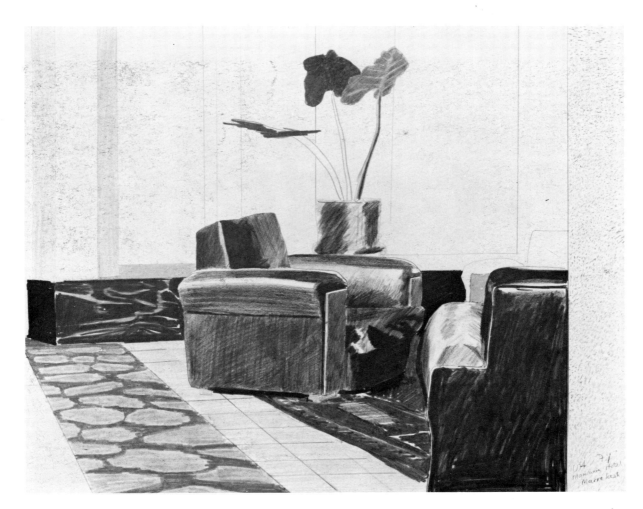

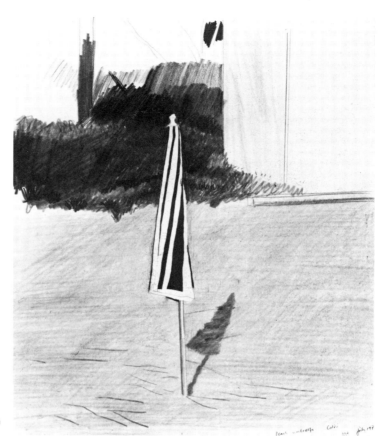

Beach Umbrella, Calvi, 1972. Crayon,
17 × 14 (43 × 35·5).

Hotel Garden, Vichy, 1972. Acrylic on
canvas, 36 × 48 (91·4 × 122).

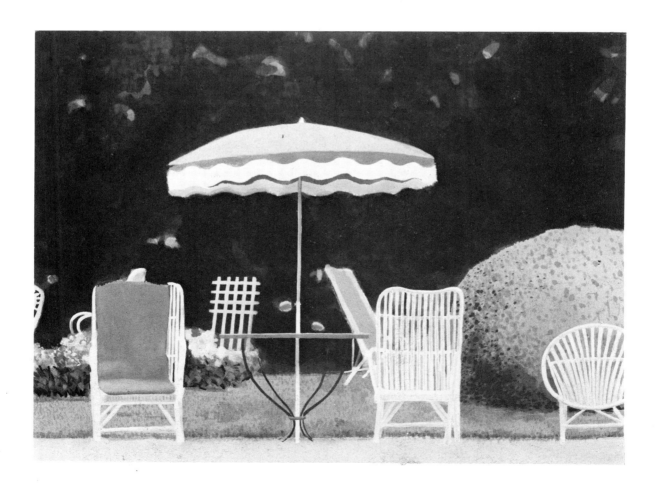

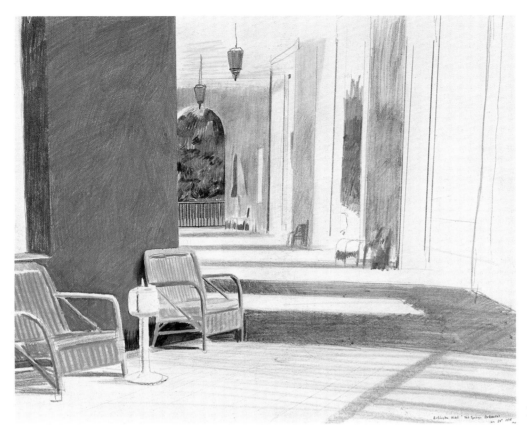

Arlington Hotel, Hot Springs, Arkansas,
1976. Crayon, 14 × 17 (35·5 × 43).

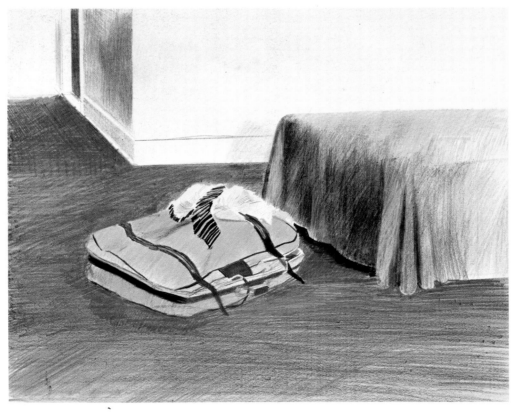

Hotel Room, Hot Springs, Arkansas, 1976.
Crayon, 14 × 17 (35·5 × 43).

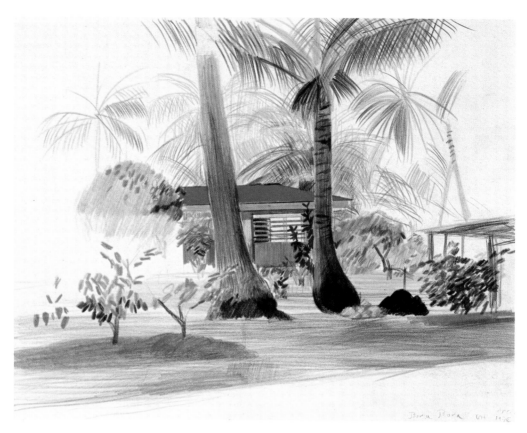

Bora Bora, 1976. Crayon, 14 × 17 (35·5 × 43).

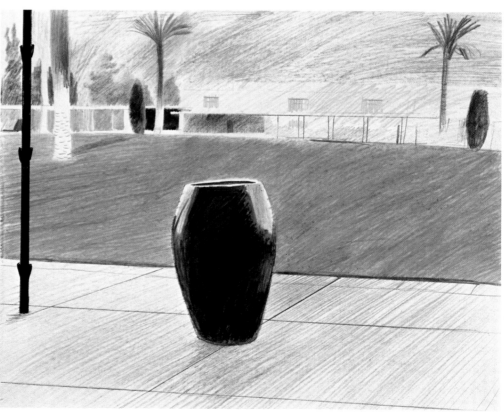

Large Pot, Arizona Biltmore, 1976. Crayon, 14 × 17 (35·5 × 43).

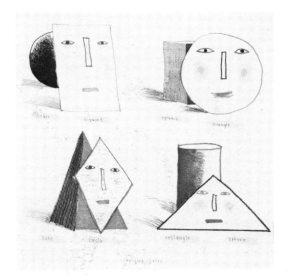

Inventions and illustrations

I did a small strange painting, that at first people didn't understand, thought it was a bit odd. It's an invented figure, a check man, with a real still life, and the man is moving a curtain which is painted from a Fra Angelico painting, lifted straight from it. It's called *Invented Man Revealing a Still Life*. I feel that there's nothing stopping me now from painting almost anything, even just some stripes if I want; it can all fit in with a view. I've got lots of pictures I want to do, and I just want to go and invent them.

Simplified Faces (State2), 1974. Etching, 22 × 20 (56 × 51).

(Untitled) inscribed on back *La Vie commence à quarante ans*, 1976. Acrylic on canvas, 14 × 18 (35·5 × 46·2).

Showing Maurice the Sugar Lift, 1974.
Etching, 36 × 28 (92 × 72).

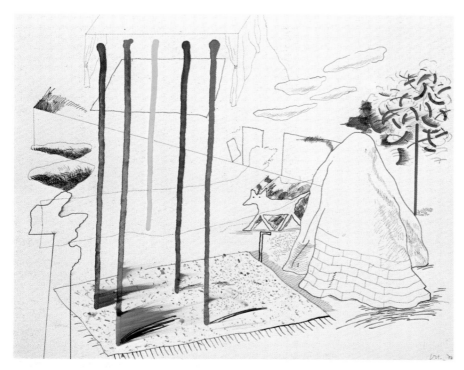

Blue Guitar series: *Running Colours with Brick Mountain*, 1976. Drawing for etching in *The Man with the Blue Guitar*, coloured inks, 14 × 17 (35·5 × 43).

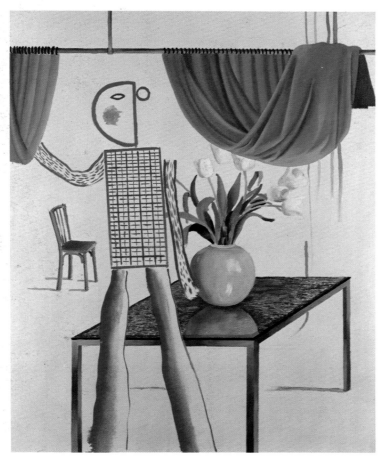

Invented Man Revealing Still Life, 1975. Oil on canvas, 36 × 28½ (91·4 × 72·4).

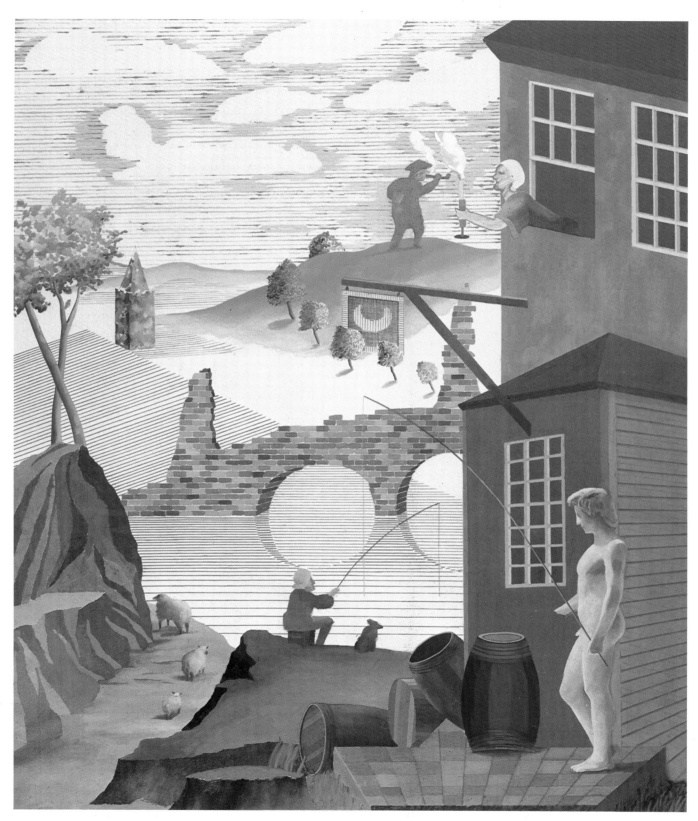

Kerby (After Hogarth) Useful Knowledge, 1975. Oil on canvas, 72 × 60 (183 × 152·4).

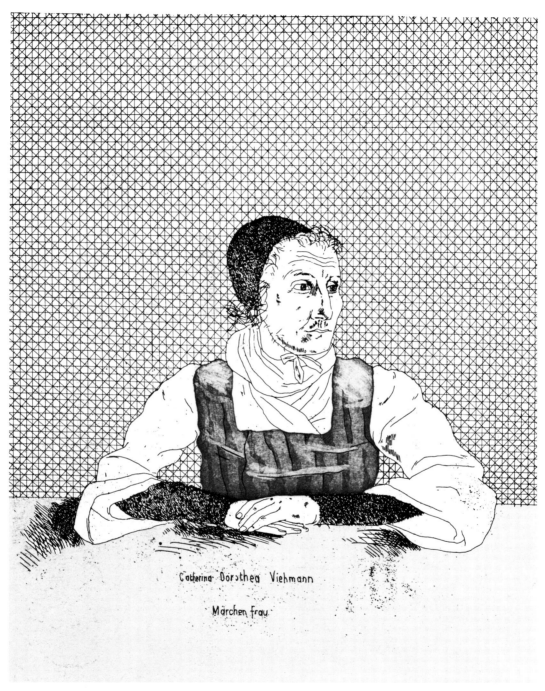

Within the image: Catherina Dorsthea Viehmann / Märchen Frau.

Catherina Dorothea Viehmann, 1969. Etching and aquatint on copper, 11 × 9 (28 × 24).

Portrait of Cavafy II, 1966. Etching and aquatint, 14 × 9 (36 × 23).

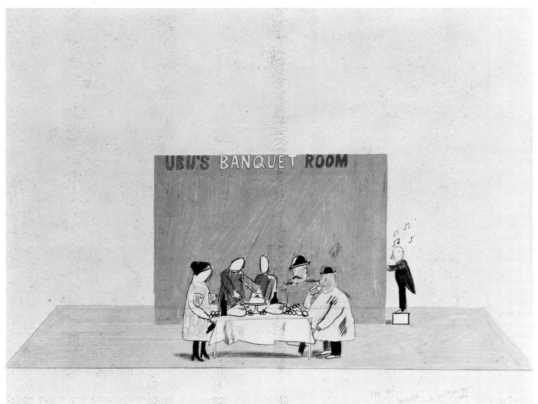

Sets

In painting I had been interested in theatrical devices, and I thought that in the theatre, the home of theatrical devices, they'd be different, they wouldn't have quite the same meaning as they do in painting, they wouldn't be contradictory – a theatrical device in the theatre is what you'd expect to find. For me, theatre design is the making of pictures on the stage.

Ubu's Banquet with Conveyor-Belt Table, 1966. Crayon, 14½ × 19½ (37 × 50).

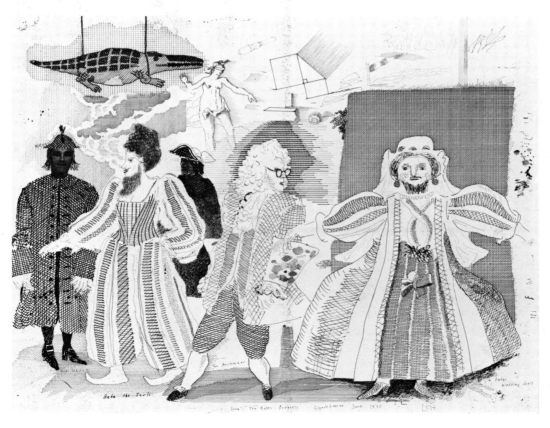

Sketch for *The Rake's Progress*, 1975. Coloured inks and watercolour, 14 × 17 (35·5 × 43).

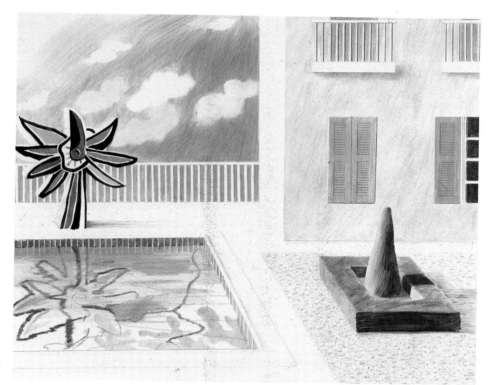

Drawing for the design for Roland Petit's ballet *Septentrion*, 1975. Crayon, 14 × 17 (35·5 × 43).

A set from the Glyndebourne production of *The Magic Flute*, 1978.

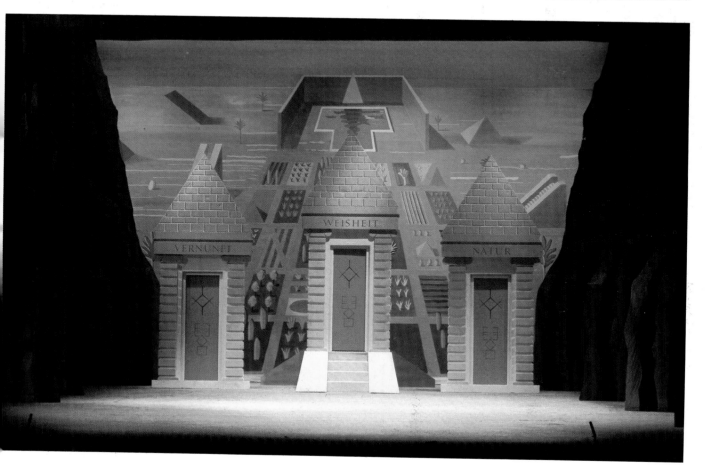

Acknowledgments

Numbers indicate the page on which the illustration is reproduced.
t = top b = bottom l = left r = right

Ludwig Collection, Aachen 6, 106 b, 107

Harry N. Abrams Family Collection, New York 29, 35, 55, 73 t

Sir Robert Adeane, London 52 t

The Artist 64, 65, 66, 67, 68, 73 b, 76 t, 76 b, 78 t, 78 b, 79, 94 t, 106 t, 118 b, 119 b

Photo Claude Bernard 97

Bruno Bischofberger, Zurich 14

Photo Brompton 14

Photo Geoffrey Clements 33, 37 t, 38, 41, 44 tl, 54 t

Peter Coni 84

Photo A. C. Cooper 28, 29, 31, 44 tr, 48 t, 118 t

Photo Prudence Cuming Associates Ltd 6, 15 b, 16, 18, 19, 20, 21, 26 t, 26 b, 27, 36, 50, 52 br, 55, 56 b, 57, 59, 60/61, 64, 65, 66, 67, 68, 69, 70 t, 70 b, 71, 73 b, 74 b, 75, 76 t, 76 b, 81, 83, 89, 90, 91, 92 b, 93, 94 t, 94 b, 95, 98, 102, 103, 104 t, 104 b, 109 b, 112 b, 114 t, 114 b, 115, 118 b, 119 t

Photo Cuming Wright-Watson 22, 35, 39 t, 39 b, 40, 43, 45 b, 48 b. 51, 54 b, 56 t, 74 t, 77, 80, 82 b, 85, 86 t, 86 b, 87 t, 87 b, 92 t, 96, 108 t, 108 b, 109 t

Dr Wilhelm Dansmann, Hamburg 44 tl

Mr and Mrs Denman, Washington, USA 38

Louisiana Museum, Denmark 58

Photo John Donat 17

The Marquess of Dufferin and Ava 21, 40, 51, 87 b

William Evans, Kansas City, USA 80, 86 t, 114 b

Mr and Mrs Fiterman 71

Fulton Art Gallery, New York 104 t

Henry Geldzahler, New York 72 t

Dr Guenther Gercken, Luetjensee, Germany 53 t

Mr and Mrs Thomas Gibson, London 87 t

Photo Guy Gravett, 119 b

Lord Hartington, London 74 b

R. B. Kitaj, London 91

Knoedler Kasmin Ltd 26 t, 26 b, 27, 52 br, 60/61, 70 b, 86 b

Jean Leger, Paris 100

Mrs M. Littman, London 82 b

British Museum, London 109 t

Mr and Mrs Ehepaar Lueg, Dortmund 36

Herbert Meyer-Ellinger, Frankfurt a.m. 42

Hans Neuendorf, Hamburg 54 b

Museum of Modern Art, New York 115

Mrs B. Organ, Wolverton 45 b

Petersburg Press 48 b

Presented by the C.A.S., London, to the National Gallery of Victoria, Melbourne 23

Private collection 32, 34, 37 t, 39, 41

Private collection, Belgium 92 b, 102

Private collection, Bradford 44 br

Private collection, Chicago 56 b, 69

Private collection, Germany 16, 17, 19, 30, 42, 53 b, 98, 105 tl, 108 t

Private collection, Hong Kong 33, 57

Private collection, Italy 37 b

Private collection, London, promised gift to National Portrait Gallery, London 74 t

Private collection, London 25, 49, 56 t, 70 t, 88, 89, 92 t, 93, 94 b, 95, 96, 103, 112 b, 118 t

Private collection, Los Angeles 22, 39 t, 47, 62

Private collection, New York City 46

Private collection, Paris 97

Private collection, Switzerland 18, 20, 31, 43, 82 t

Private collection, UK 15 t, 28, 50, 59, 77, 109 b

Private collection, USA 81, 85, 101, 105 tl, 105 tr, 105 b, 110 t, 110 b, 111 t, 111 b, 119 t

Mr and Mrs Selfe, Alabama 90

Hans Edmund Siemers, Hamburg 44 tr

Tate Gallery, London 24 t, 75

Photo Frank J. Thomas 46, 62, 72 b, 82 t, 84, 105 tl, 105 tr, 105 b, 110 t, 110 b, 111 t, 111 b

Photo R. Todd-White 32, 37 b, 45 t, 73 t, 88

Photo Kenneth Tyler 63

Albertina Museum, Vienna 114 t

Waddington Galleries, London 83

Walker Art Gallery, Liverpool 54 t

Photo John Webb 23, 24 t, 25, 30, 34, 42, 49, 52 t, 53 b

Whitworth Gallery, Manchester 108 b

Photo Rodney Wright Watson 78 t, 78 b, 101, 106 t, 106 b, 107